IMPRESSIONS *of*
NEW ZEALAND

GH00370691

Produced by AA Publishing

© Automobile Association Developments Limited 2008

Published by AA Publishing (a trading name of Automobile Association
Developments Limited, whose registered office is Fanum House, Basing View,
Basingstoke, Hampshire RG21 4EA; registered number 1878835)

ISBN: 978-0-7495-5859-8
A03676

A CIP catalogue record for this book is available from the British Library.

Colour reproduction by KDP, Kingsclere
Printed and bound in China by C & C Offset Printing Co. Ltd

Opposite: Gannets at Cape Kidnappers near the North Island town of Hastings, members of a colony of 20,000 birds.

IMPRESSIONS *of*

NEW ZEALAND

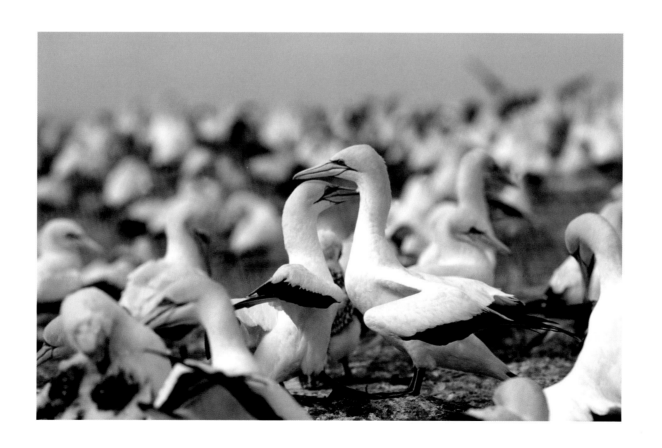

Picture Acknowledgements

The Automobile Association would like to thank the following photographers, companies
and picture libraries for their assistance in the preparation of this book.

Abbreviations for the picture credits are as follows: (AA) AA World Travel Library

3 AA/P Kenward; 5 AA/P Kenward; 7 AA/P Kenward; 8 AA/P Kenward; 9 AA/P Kenward; 10 AA/P Kenward;
11 AA/P Kenward; 12 AA/P Kenward; 13 AA/P Kenward; 14 AA/A Reisinger & V Meduna; 15 AA/P Kenward;
16 AA/P Kenward; 17 AA/P Kenward; 18 AA/A Reisinger & V Meduna; 19 AA/A Belcher; 20 AA/A Reisinger
& V Meduna; 21 AA/A Belcher; 22 AA/P Kenward; 23 AA/A Belcher; 24 AA/A Belcher; 25 AA/A Belcher;
26 AA/M Langford; 27 AA/M Langford; 28 AA/A Belcher; 29 AA/A Belcher; 30 AA/A Belcher;
31 AA/M Langford; 32 AA/M Langford; 33 AA/M Langford; 34 AA/M Langford; 35 AA/M Langford;
36 AA/M Langford; 37 AA/M Langford; 38 AA/M Langford; 39 AA/M Langford; 40 AA/M Langford;
41 AA/M Langford; 42 AA/M Langford; 43 AA/M Langford; 44 AA/M Langford; 45 AA/M Langford;
46 AA/M Langford; 47 AA/M Langford; 48 AA/M Langford; 49 AA/M Langford; 50 AA/M Langford;
51 AA/M Langford; 52 AA/M Langford; 53 AA/M Langford; 54 AA/M Langford; 55 AA/M Langford;
56 AA/M Langford; 57 AA/M Langford; 58 AA/M Langford; 59 AA/M Langford; 60 AA/M Langford;
61 AA/M Langford; 62 AA/M Langford; 63 AA/M Langford; 64 AA/M Langford; 65 AA/M Langford;
66 AA/M Langford; 67 AA/M Langford; 68 AA/M Langford; 69 AA/M Langford; 70 AA/M Langford;
71 AA/M Langford; 72 AA/M Langford; 73 AA/M Langford; 74 AA/A Reisinger; 75 AA/M Langford;
76 AA/M Langford; 77 AA/M Langford; 78 AA/M Langford; 79 AA/M Langford; 80 AA/M Langford;
81 AA/M Langford; 82 AA/M Langford; 83 AA/M Langford; 84 AA/M Langford; 85 AA/M Langford;
86 AA/M Langford; 87 AA/M Langford; 88 AA/M Langford; 89 AA/M Langford; 90 AA/P Kenward;
91 AA/P Kenward; 92 AA/P Kenward; 93 AA/M Langford; 94 AA/M Langford; 95 AA/A Reisinger & V Meduna

Every effort has been made to trace the copyright holders, and we apologise in advance for any unintentional
omissions or errors. We would be happy to apply the corrections in any following edition of this publication.

Opposite: Waves lay white icing on the rocks of one of the 144 islands of the Bay of Islands, a maritime paradise in the country's far north.

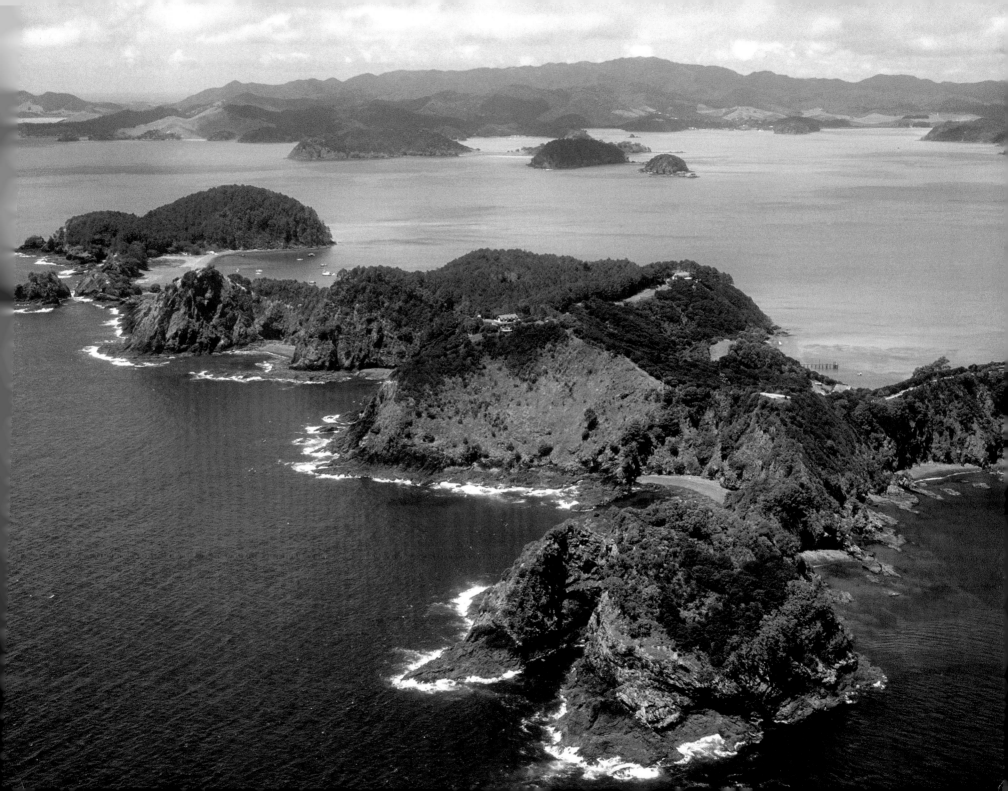

INTRODUCTION

By just about any measure you care to apply, New Zealand is an extraordinary place. Stretched across an area of 270,000 square kilometres (168,000 square miles) – just slightly larger than the United Kingdom, or about the same as the US state of Colorado – the country reads like a compendium of earthly wonders. New Zealand has rainforests, raging rivers, trout streams, the highest mountains between New Guinea and the Andes, palmy beaches where the South Pacific Ocean spills across the sand and volcanoes that spit fire and brimstone. Along the southwest coast of South Island, glaciers grinding downwards from the peaks of the Southern Alps have gouged deep fiords. This is one of the wettest parts of the planet, a place where the forest floor is upholstered with moss, and the walking tracks feel more like sponge than solid ground. Among its treasures are the Marlborough Sounds, where the sea has drowned a series of river valleys, leaving a labyrinth of waterways separated by knuckles of land.

It was also one of the very last places to feel the imprint of a human footprint. It was not until about 1250 AD that the Polynesians, who had already sailed clear across the Pacific Ocean and colonised such tiny islands as Tahiti and Hawaii, finally landed in New Zealand. Of all the world's major landmasses, only Antarctica proved more elusive. What they found was a paradise in the raw, and in particular, a paradise of birds. Of the 245 bird species in New Zealand when the Maori arrived, 176 were found nowhere else. They included the moa, the world's tallest flightless bird at almost four metres, and

Haast's eagle, the largest of the raptors. The only native land mammals were two bat species, both of which weigh about a quarter as much as a cell phone.

In this absence of canny carnivores, many birds simply forgot how to fly, laid their eggs on the forest floor and cultivated gaudy colour schemes that made a mockery of camouflage. When James Cook, the first European to set foot on New Zealand, landed at Ship Cove in the Marlborough Sounds, his botanist, Joseph Banks, wrote of waking to "the most melodious wild musick (sic) I have ever heard, almost imitating small bells". Although the volume is probably lower now that those forests have shrunk, that same music will be familiar to anyone who spends a night near a New Zealand woodland.

In a crowded world that is increasingly choked with traffic, carbon emissions and electronic bleatings, New Zealand often feels like a page from the past. Its population of just over four million is concentrated in a few major urban centres. The rest of the country feels like a cross between a golf course, a sheep pasture and a wilderness reserve.

There are few other places that so stridently summon you out into the great outdoors and persuade you to do something intrepid. For the traveller in search of adventure – whether that adventure involves crampons and an ice axe or a seat by the window from which to watch the scenery unfold – there's nowhere else quite like it.

Opposite: A quiet evening on Lake Te Anau against the beech forests of the Fiordland ranges.

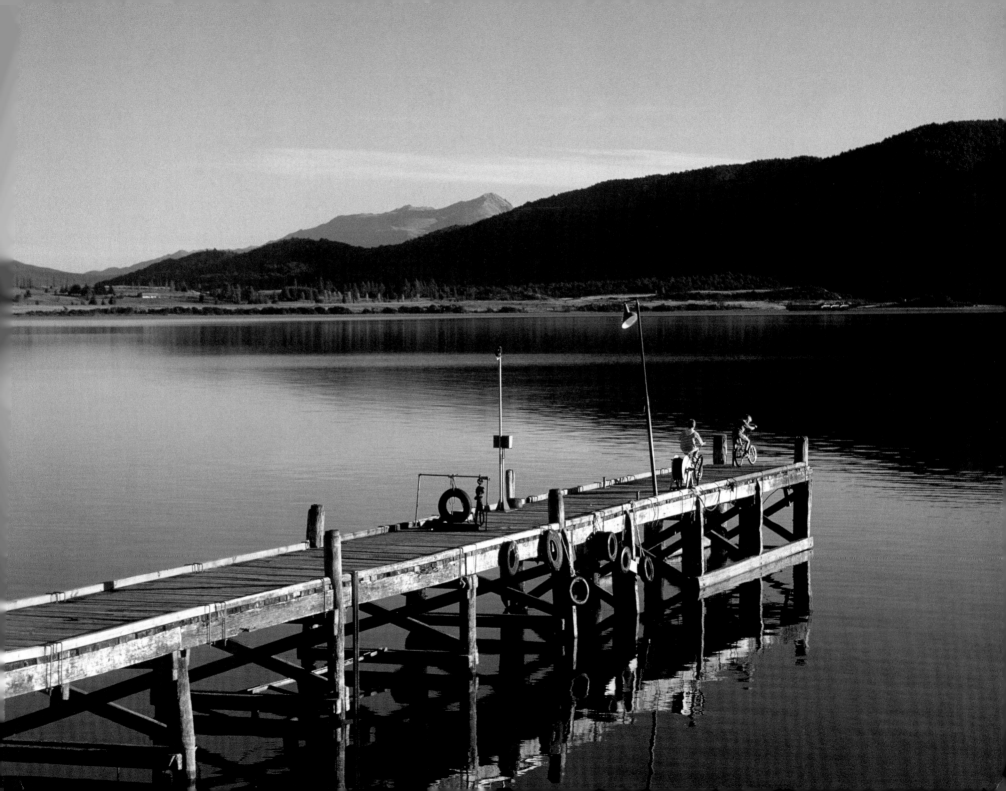

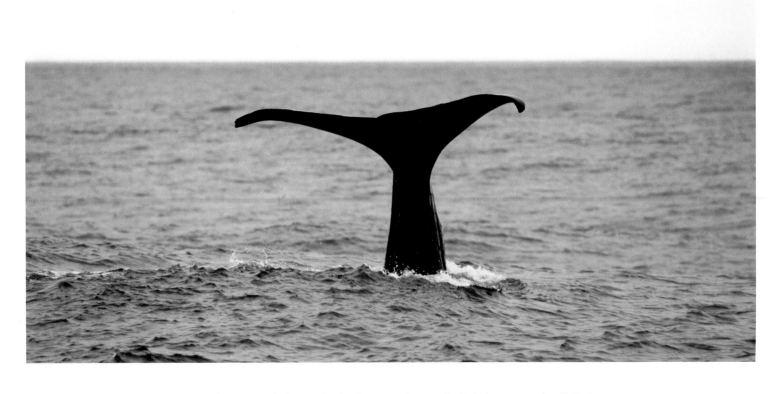

The tail of a sperm whale in a final salute as it dives to feed in the sea trench off Kaikoura.

Opposite: The misty peaks of the Kaikoura Ranges, which give this coastline its subtitle "where the mountains meet the sea".

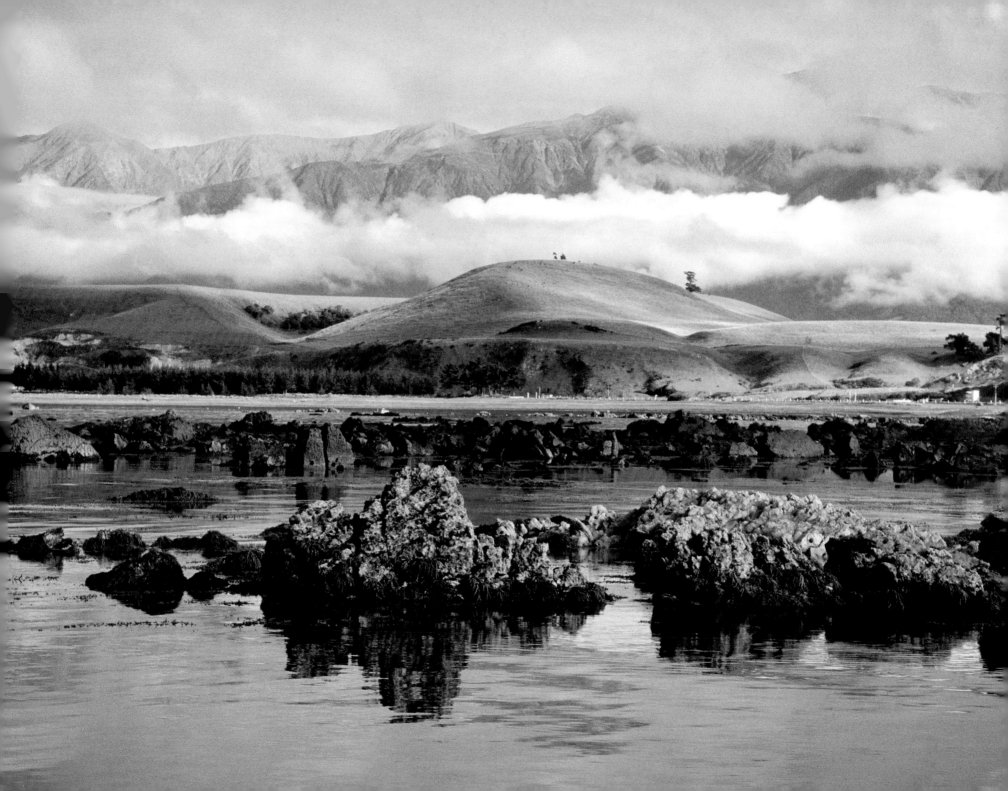

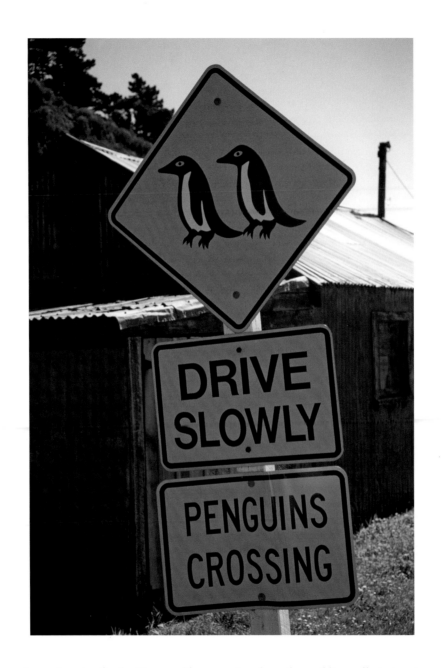

A warning sign for the Oamaru blue penguin colony, the world's smallest penguin.

Boiling mud pools in the Craters of the Moon thermal area in the Wairakei Tourist Park near Taupo.

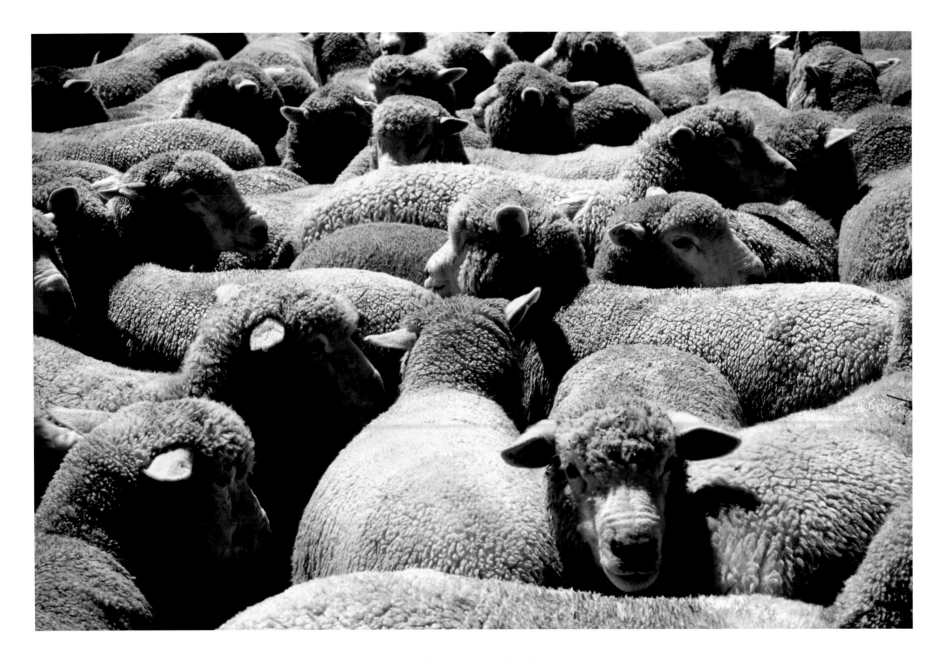

A mob of sheep mustered in preparation for shearing, Kaipiti Coast.

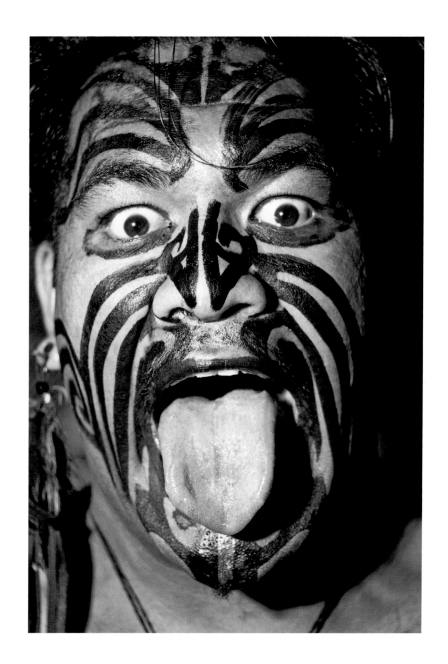

A Maori warrior with traditional moko face painting performs in a haka at Queenstown.

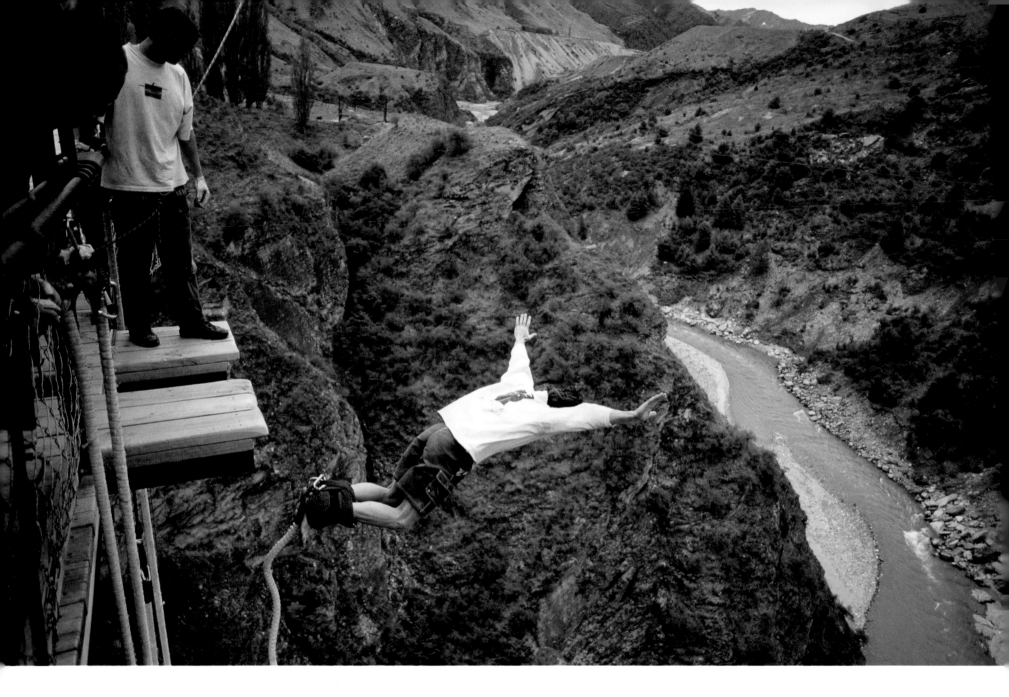

A bungy jumper makes the leap of faith at the Pipeline Bungy, 102 metres (335 feet) above the Shotover River near Queenstown.

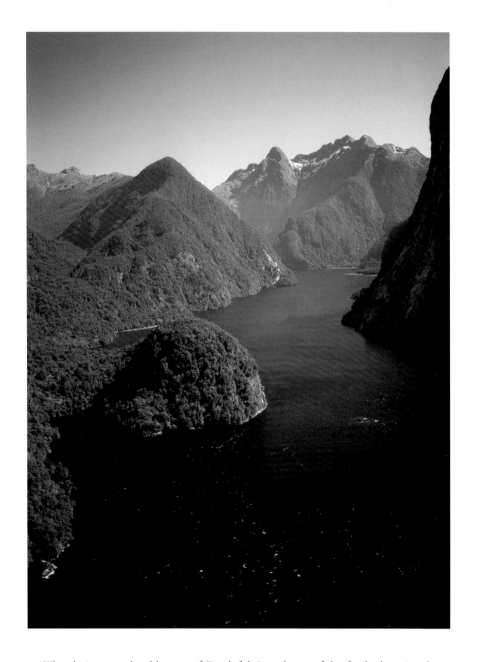

The glacier-carved wilderness of Doubtful Sound, one of the fiords that give the southwest coast of South Island its tattered edge.

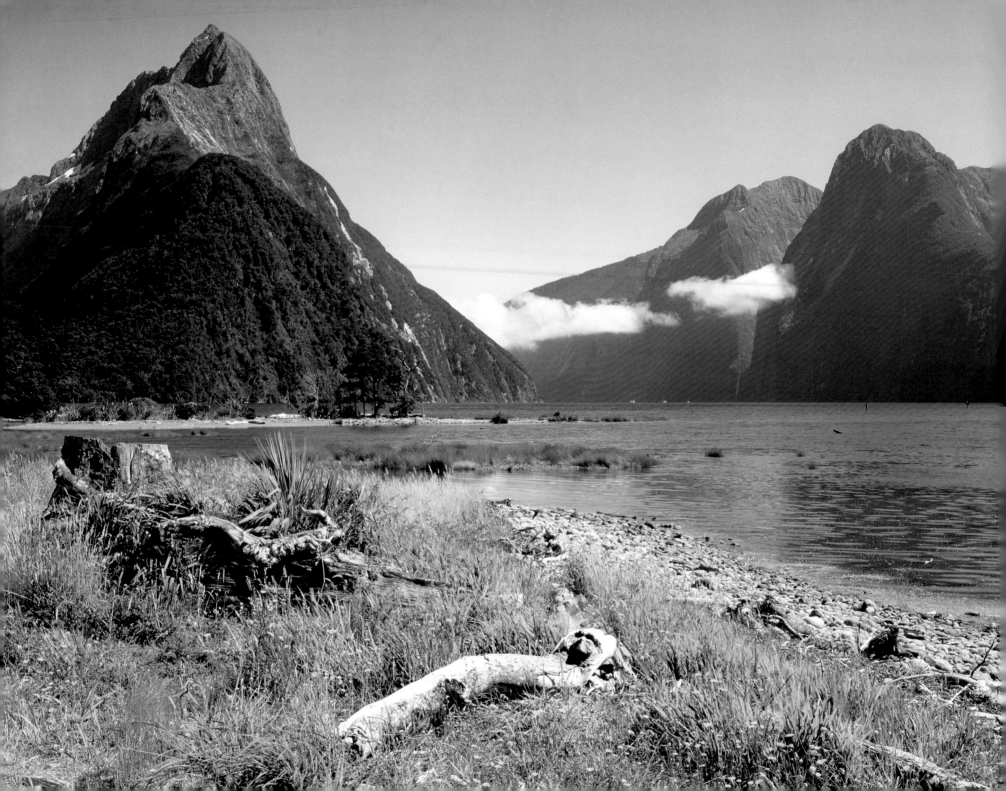

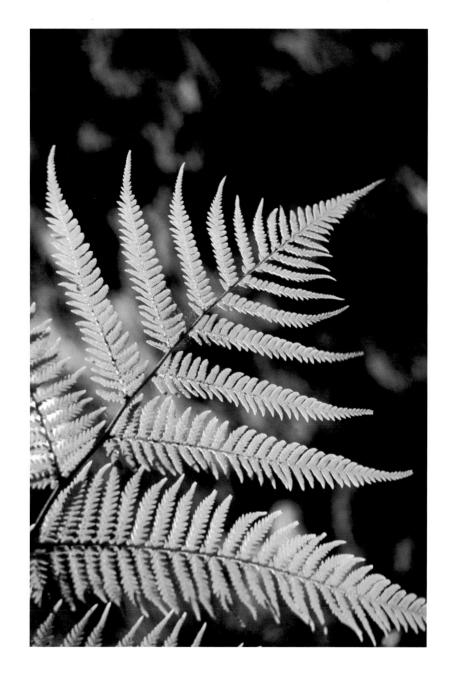

The silver fern, New Zealand's national symbol.

Opposite: Wildflowers on the shoreline of Milford Sound, bracketed by Mitre Peak (left), The Elephant (centre) and The Lion (right).

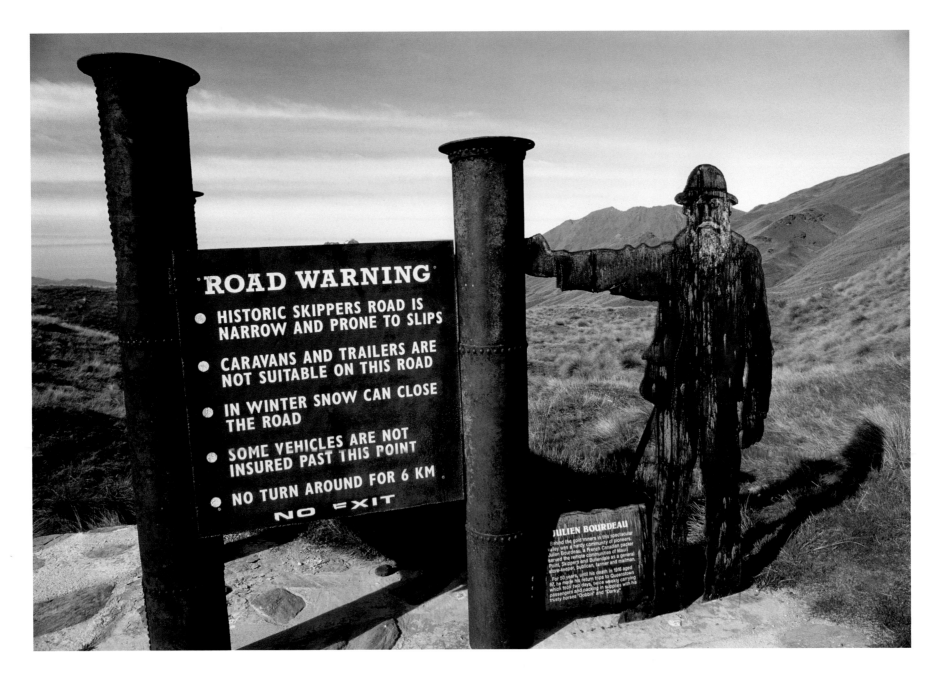

ROAD WARNING

• HISTORIC SKIPPERS ROAD IS NARROW AND PRONE TO SLIPS

• CARAVANS AND TRAILERS ARE NOT SUITABLE ON THIS ROAD

• IN WINTER SNOW CAN CLOSE THE ROAD

• SOME VEHICLES ARE NOT INSURED PAST THIS POINT

• NO TURN AROUND FOR 6 KM

NO EXIT

JULIEN BOURDEAU

Behind the gold miners in this spectacular valley was a hardy community of pioneers. Julien Bourdeau, a French Canadian packer served the remote communities of Maori Point, Skippers and Bullendale as a general store-keeper, publican, farmer and mailman. For 50 years, until his death in 1916 aged 87, he made his return trips to Queenstown which took two days, twice weekly carrying passengers and packing in supplies with his trusty horses "Dobbin" and "Darky".

A warning sign at the start of Skippers Road, Queenstown.

18

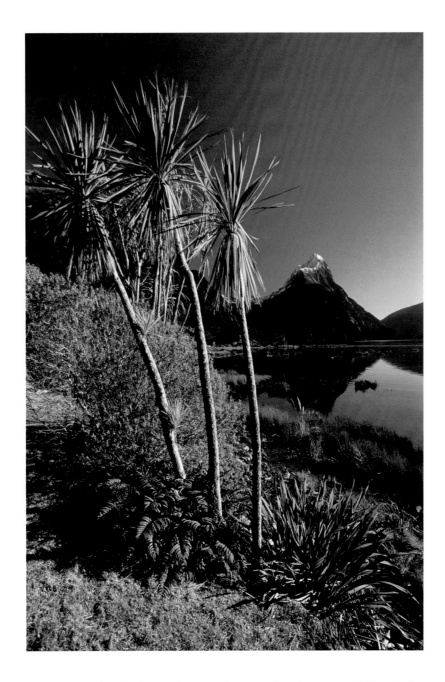

The shores of Milford Sound against the snow-dusted summit of Mitre Peak.

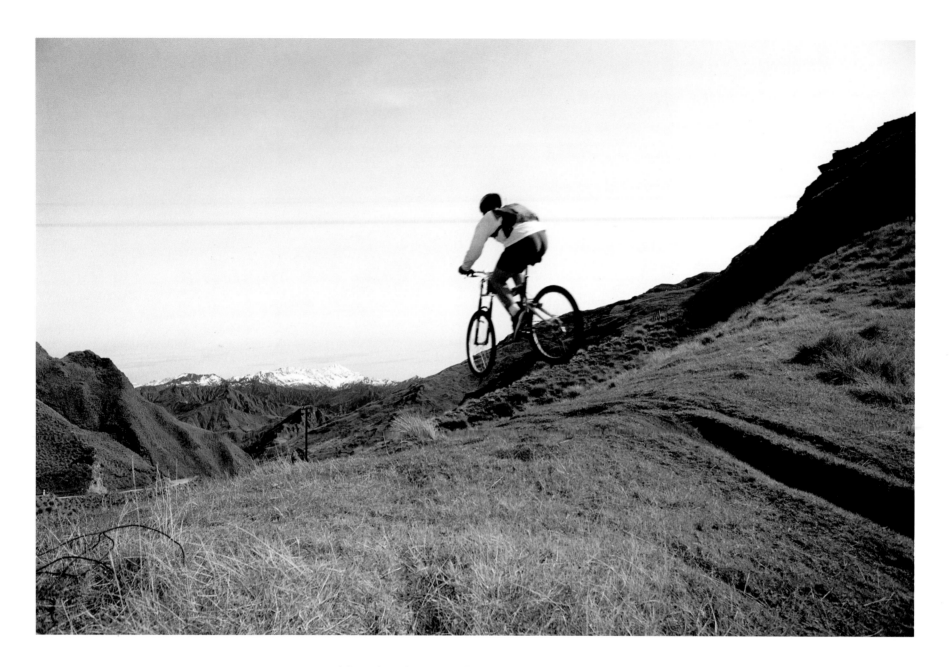

Mountain biking through Long Gully towards Skippers Road, Queenstown.

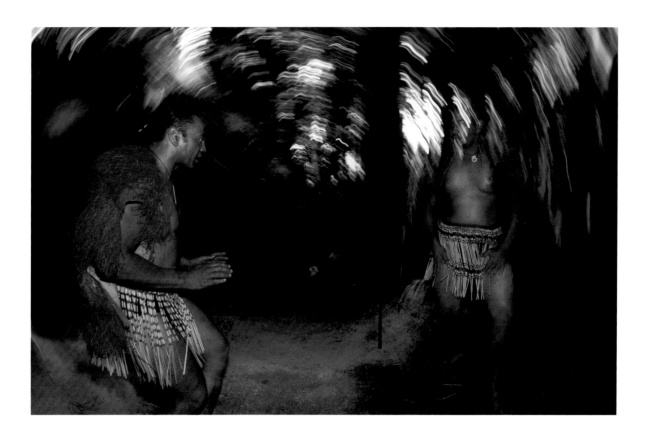

Maori warriors perform a haka at Tamaki Village in Rotorua.

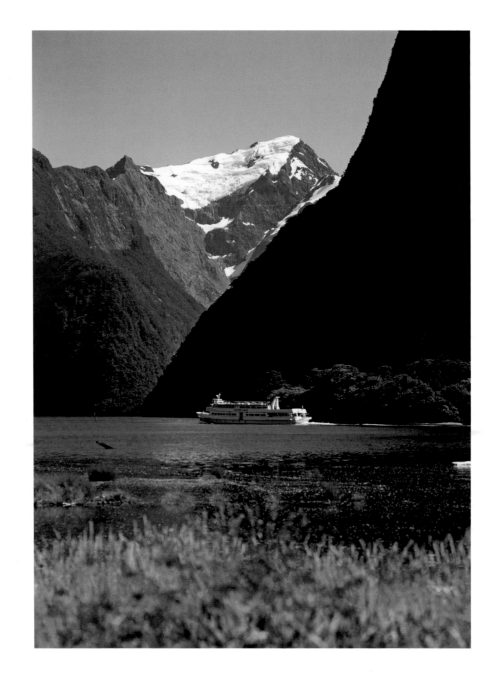

Dwarfed by peaks that leap into the sky, a tour boat threads through Milford Sound.

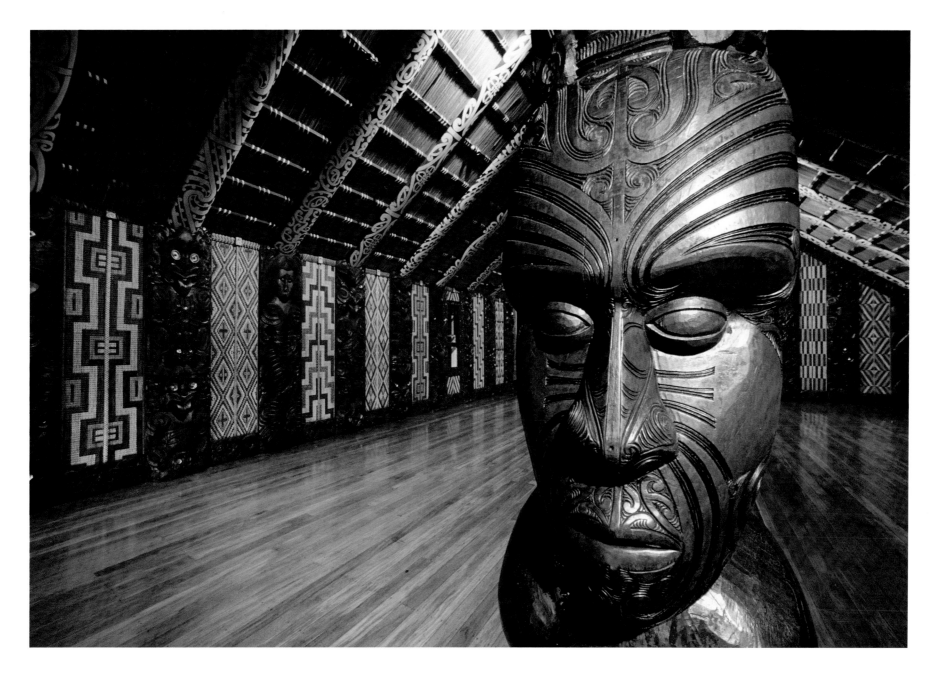

Detail of a carving in the Whare Runanga (meeting house), built at Waitangi Treaty Grounds in 1940, the centenary year of the Treaty of Waitangi.

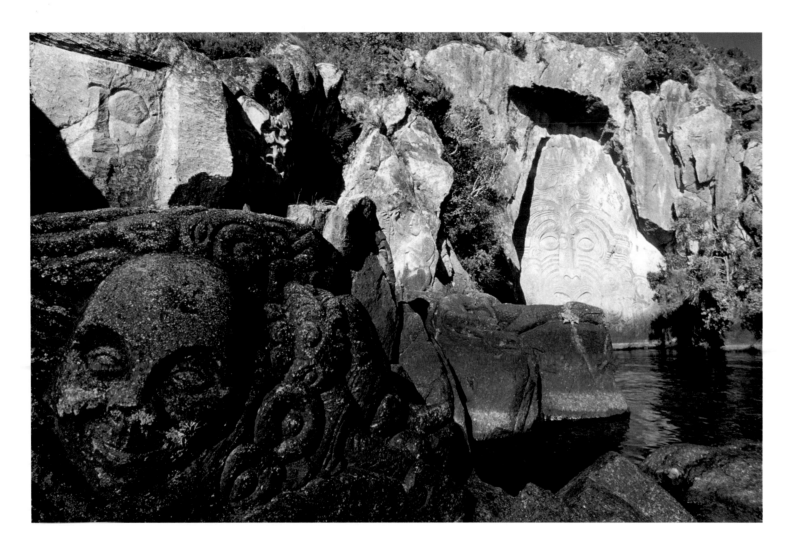

Detail of a Maori Rock carving at Lake Taupo.

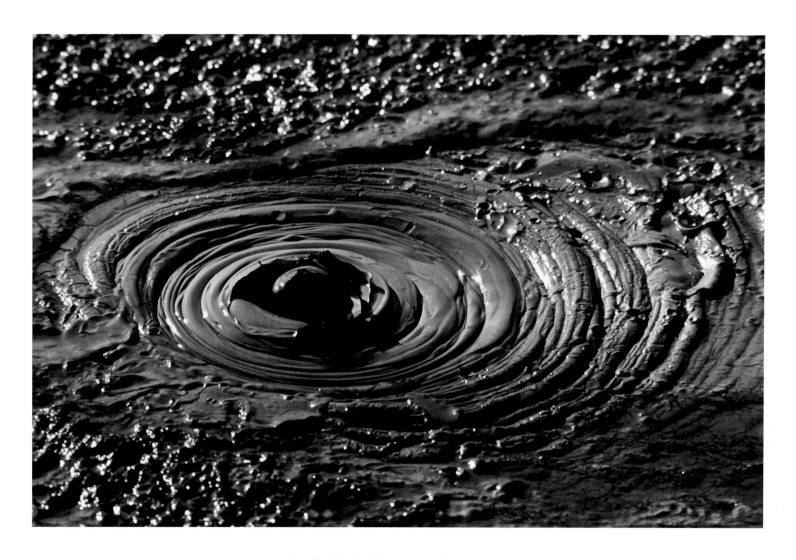

Detail of the bubbling mud pools at Rotorua.

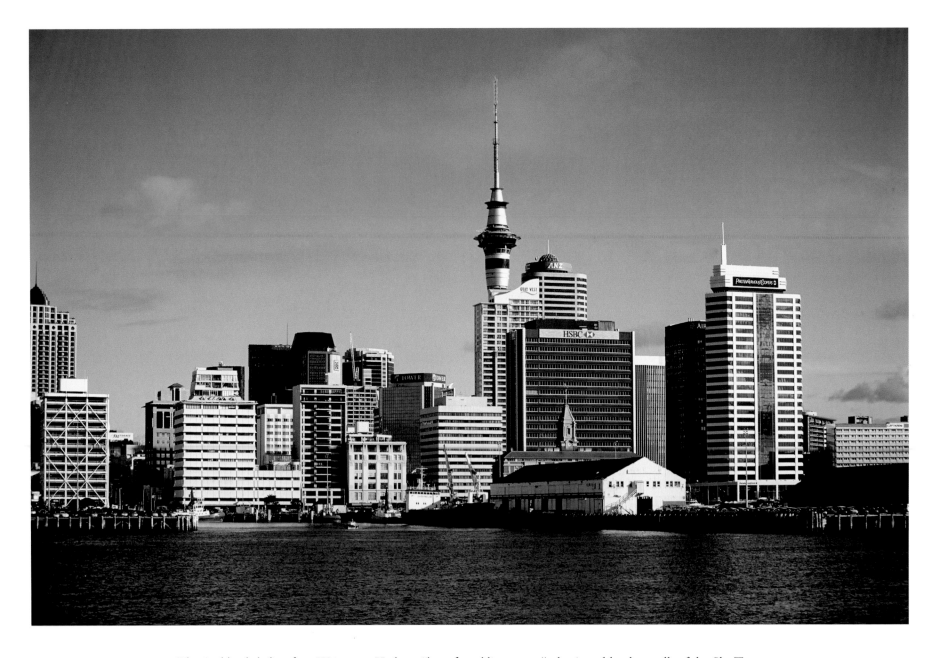

The Auckland skyline from Waitemata Harbour, "bay of sparkling waters", dominated by the needle of the Sky Tower.

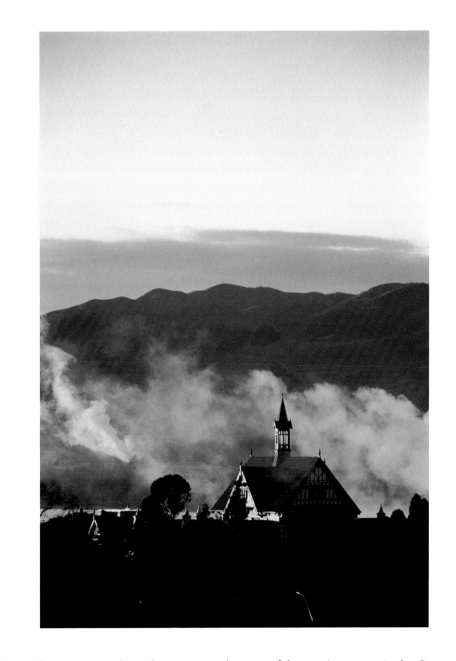

A plume of steam from Rotorua's thermal area caresses the tower of the town's museum in the Government Gardens.

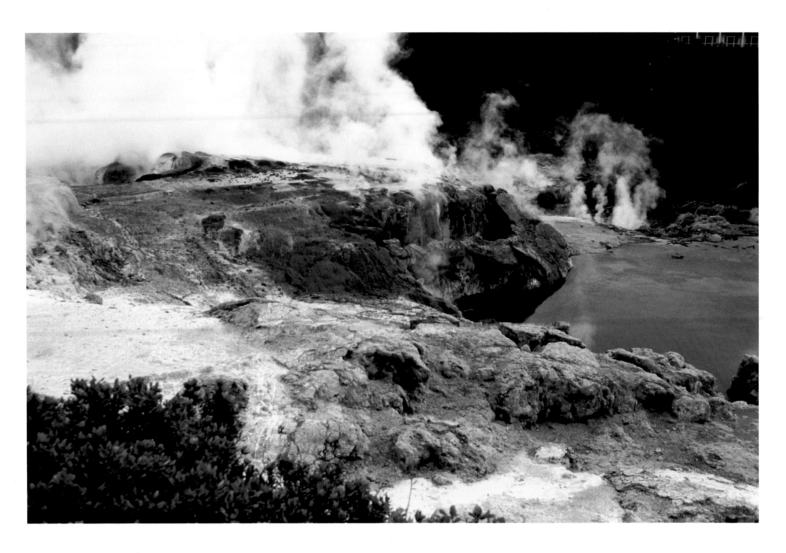

Steam rises from a silica deposit in the Waimangu Valley thermal area outside Rotorua.

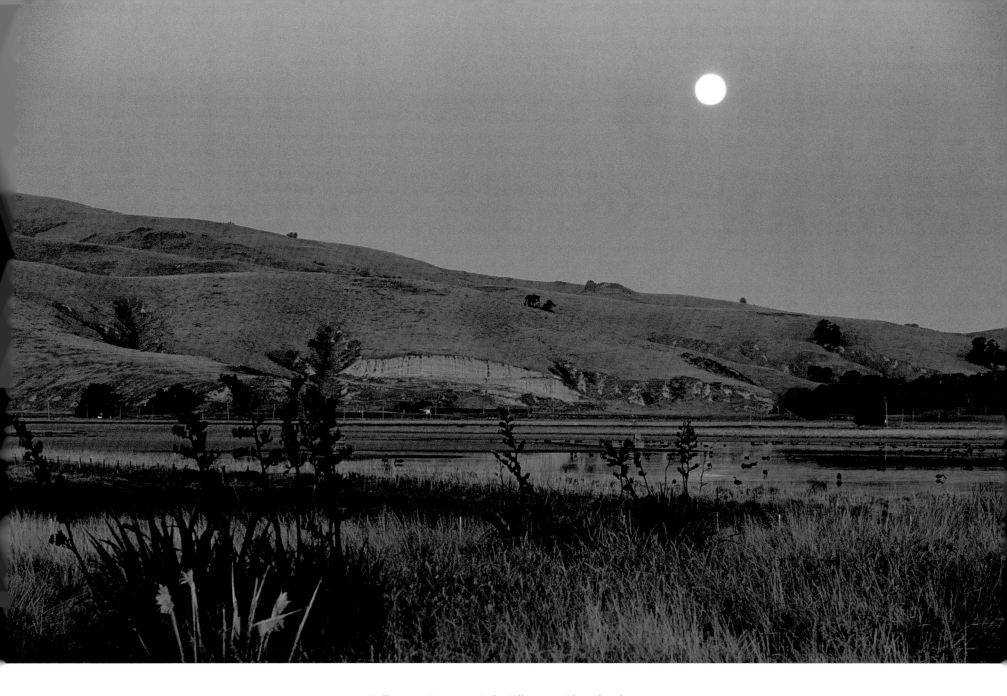

Full moon rising over Lake Ellesmore, Christchurch.

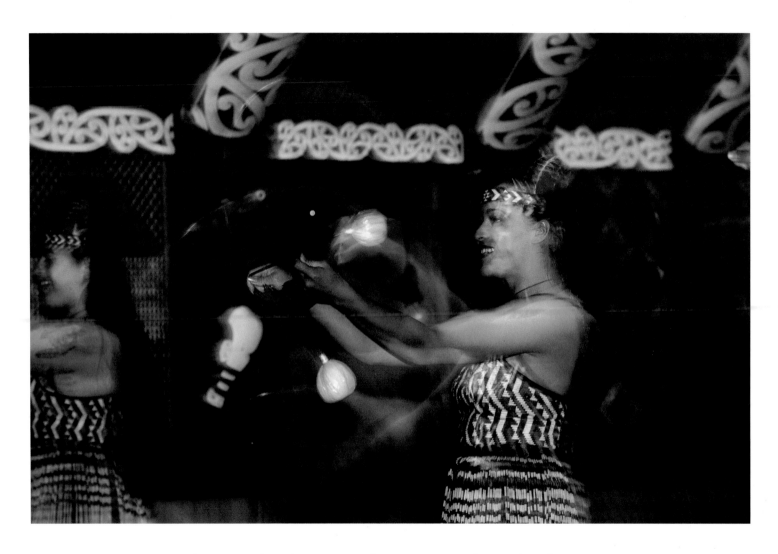

Performing a traditional Poi Dance at the Maori Institute of Arts and Crafts, Rotorua.

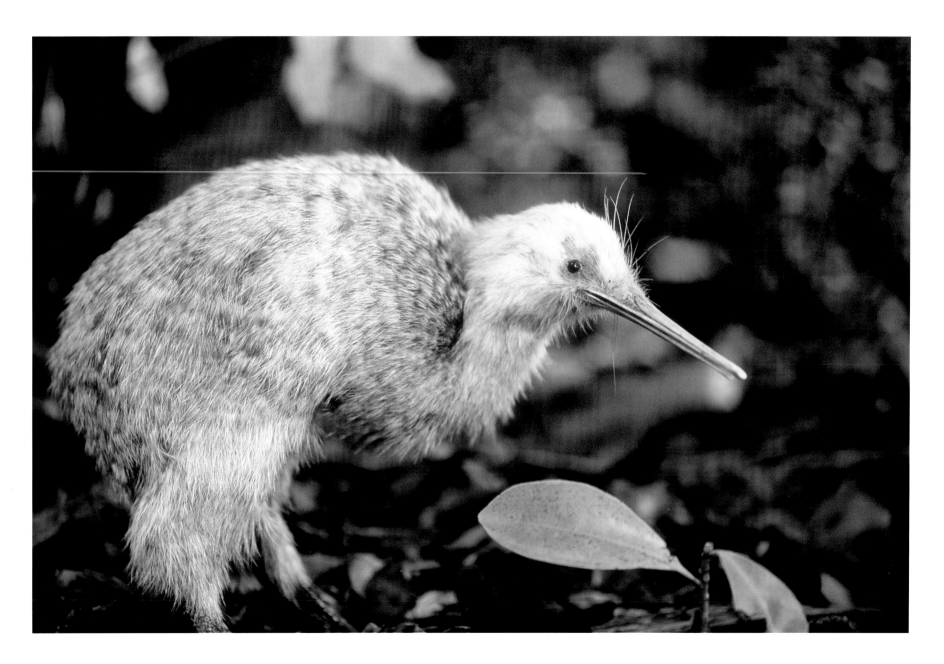

Close up of a kiwi at Nga Manu Nature Reserve at Waikane.

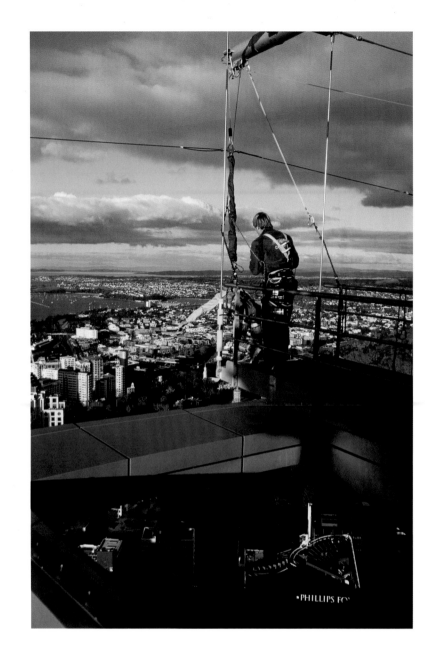

A jumper prepares for the final countdown on the Sky Jump platform at Auckland's Sky Tower.
Opposite: Cape Kidnappers, named by Captain James Cook after local Maori tried to kidnap one of his crew.

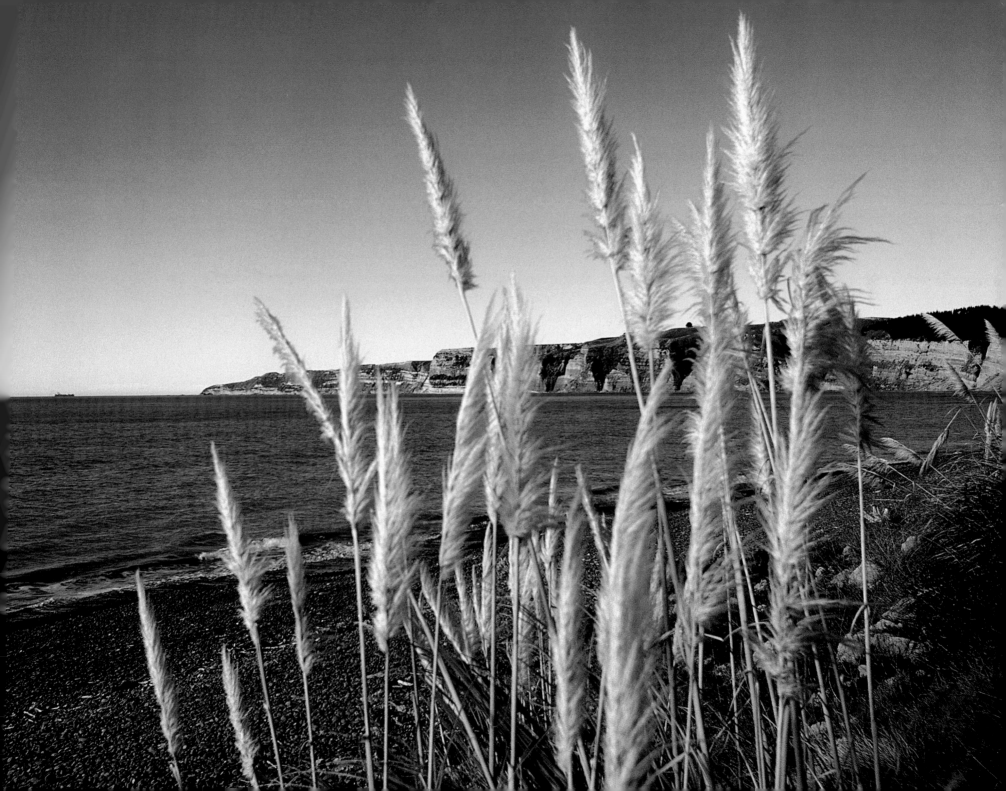

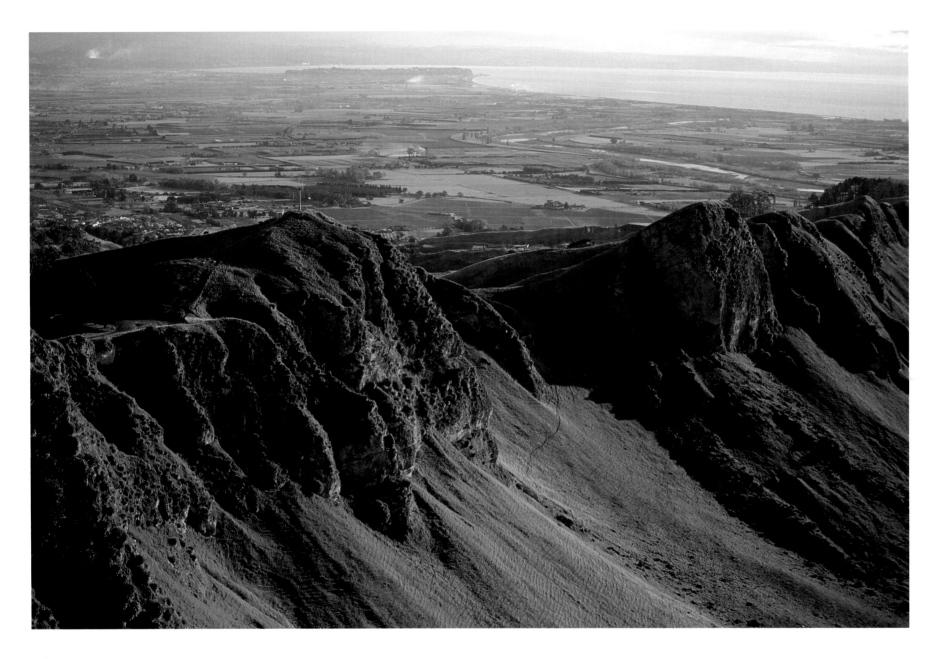

The view from Te Mata Peak over the coastal landscape of Hastings, Hawkes Bay.

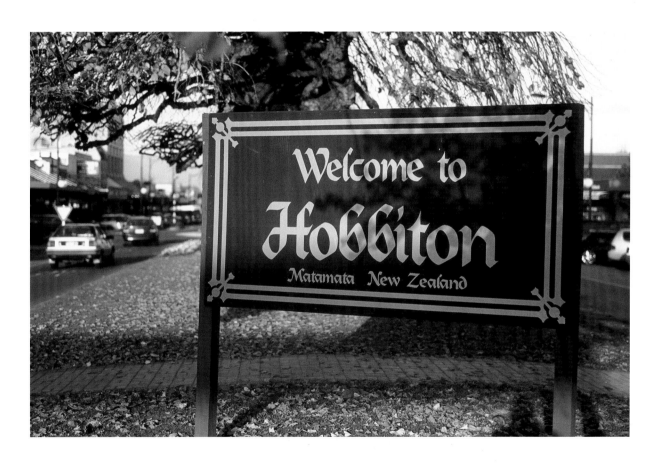

Town sign in Matamata, setting for the Hobbiton scenes in the film The Lord of the Rings.

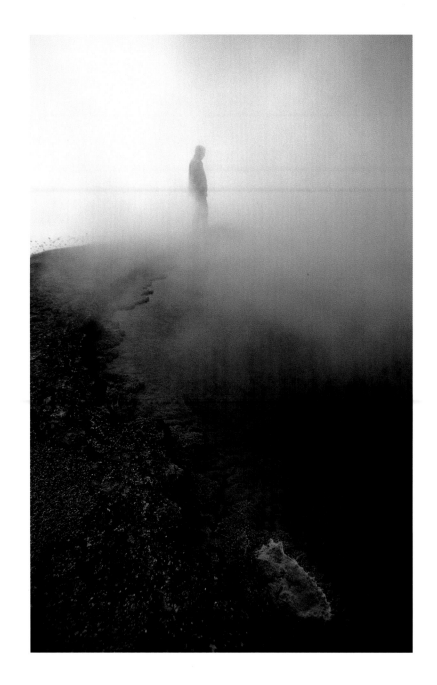

Steam rising from the Champagne Pool shrouds a figure at the Wai-O-Tapu Thermal Wonderland near Rotorua.

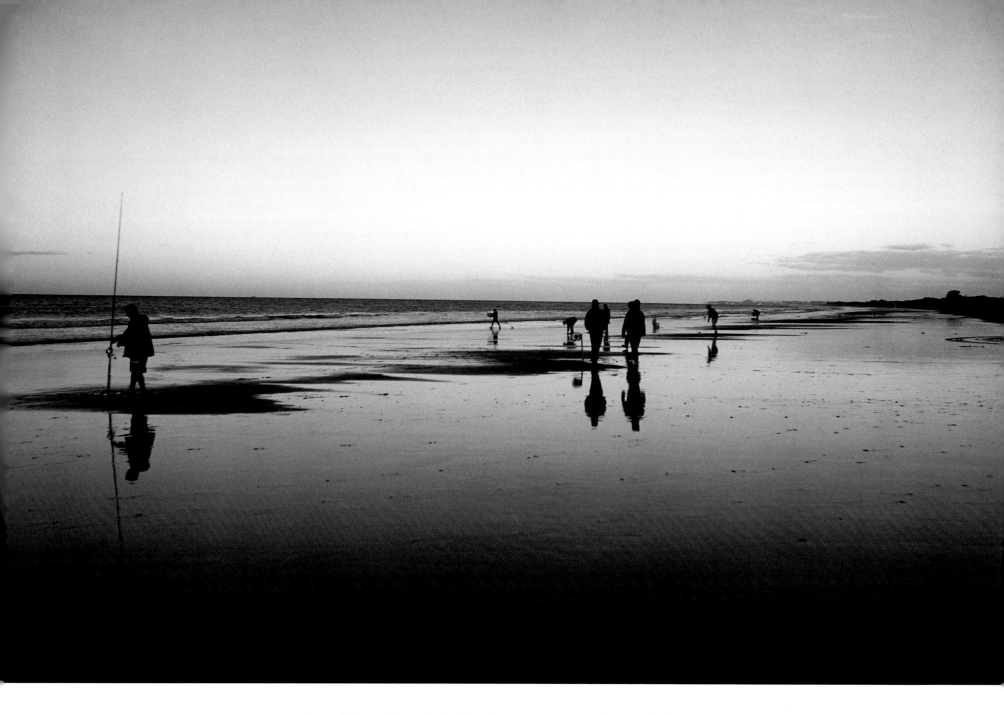

Sunset brings a glow to the beach at Mount Manganui, on the Bay of Plenty.

A sculpture at the Driving Creek Potteries and Railway on the Coromandel Peninsula.

Produce for sale at a roadside stall on the Coromandel Peninsula.

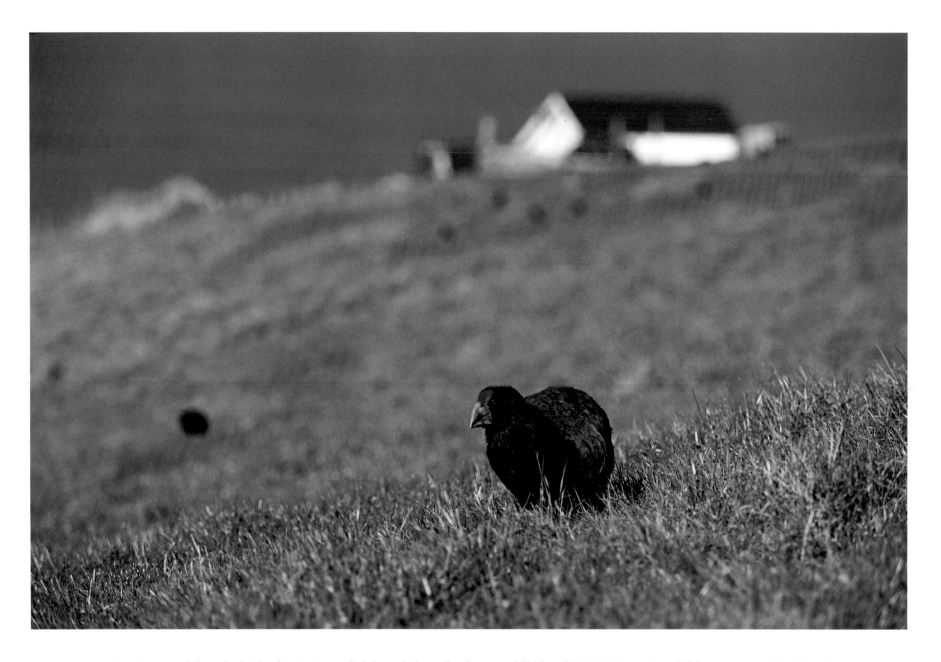

A species rescued from the brink of extinction, a flightless takahe stalks the grassy hillsides of Tiritiri Matangi, a wildlife sanctuary in the Hauraki Gulf off the coast of Auckland.

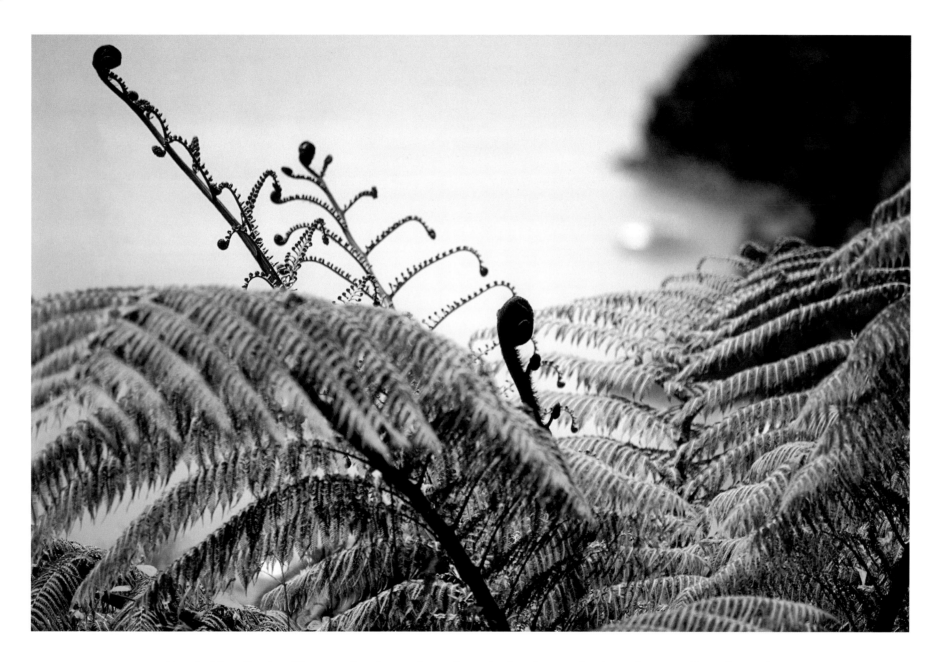

Detail of ferns found on Kenepuru Sounds, one of many bays, islands and peninsulas that make up Marlborough Sounds.

A guide at the Monteith's Brewery in Greymouth takes visitors through the brewing process.

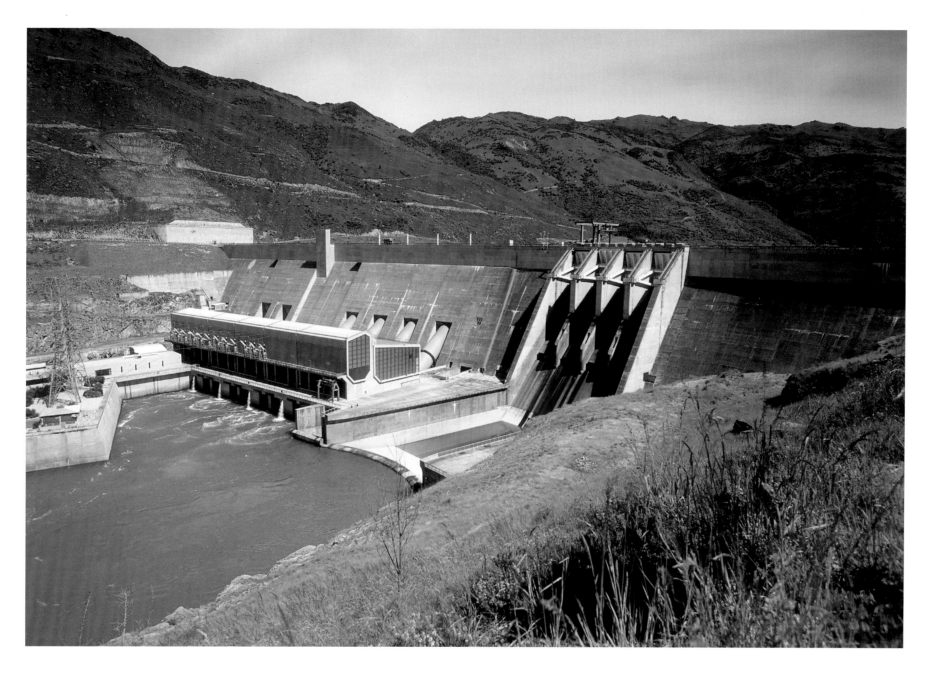

Clyde Dam, which was completed in 1989, in Central Otago.

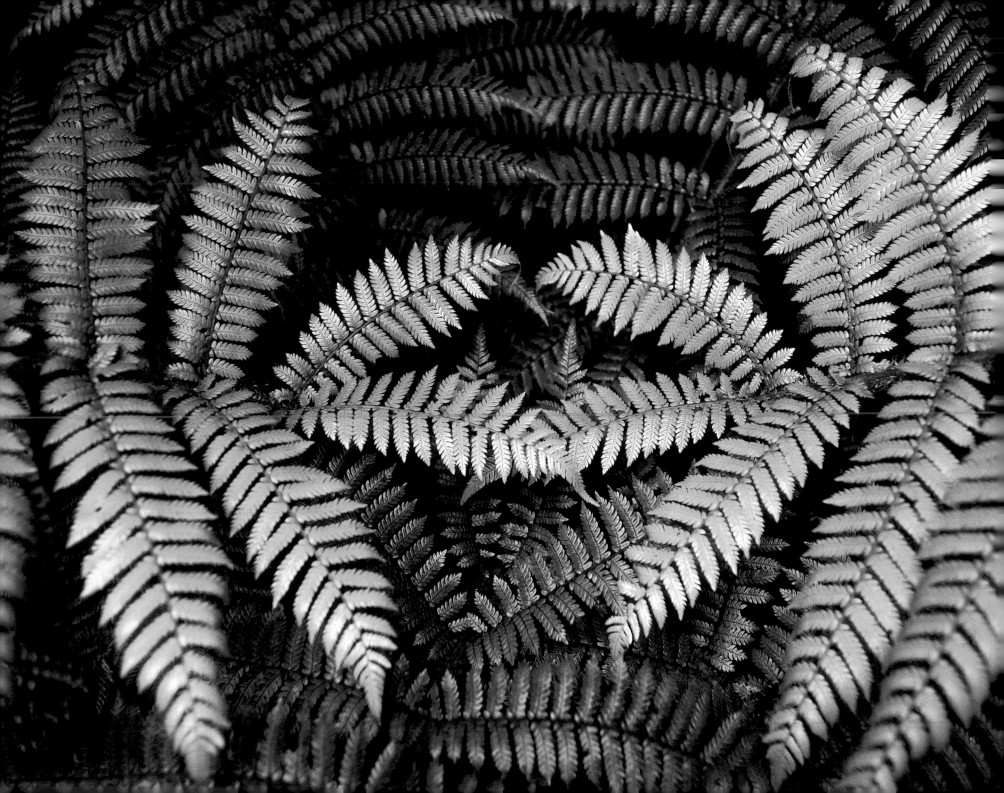

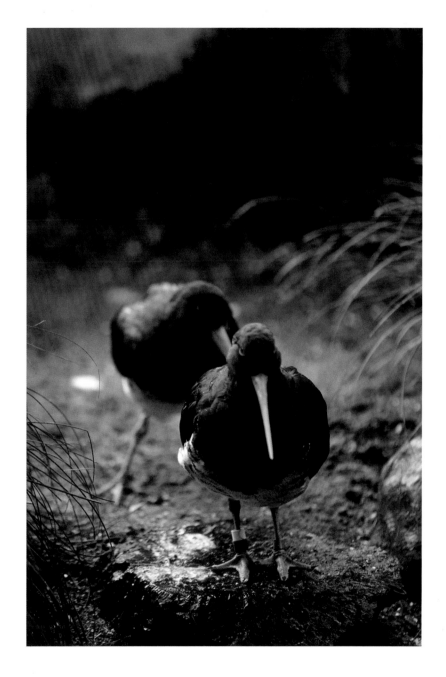

Oyster catchers in the Kiwi House and Native Bird Park, Otorohanga.
Opposite: Fern fronds make a lacy understorey against the forest floor around Lake Matheson, Westland.

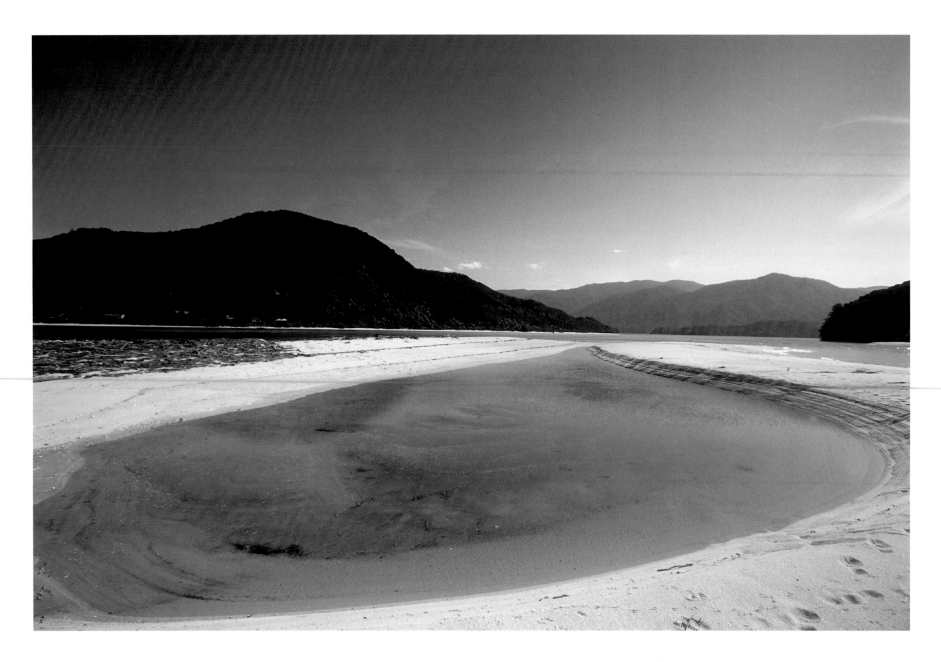

The Awaroa Inlet in Abel Tasman National Park.

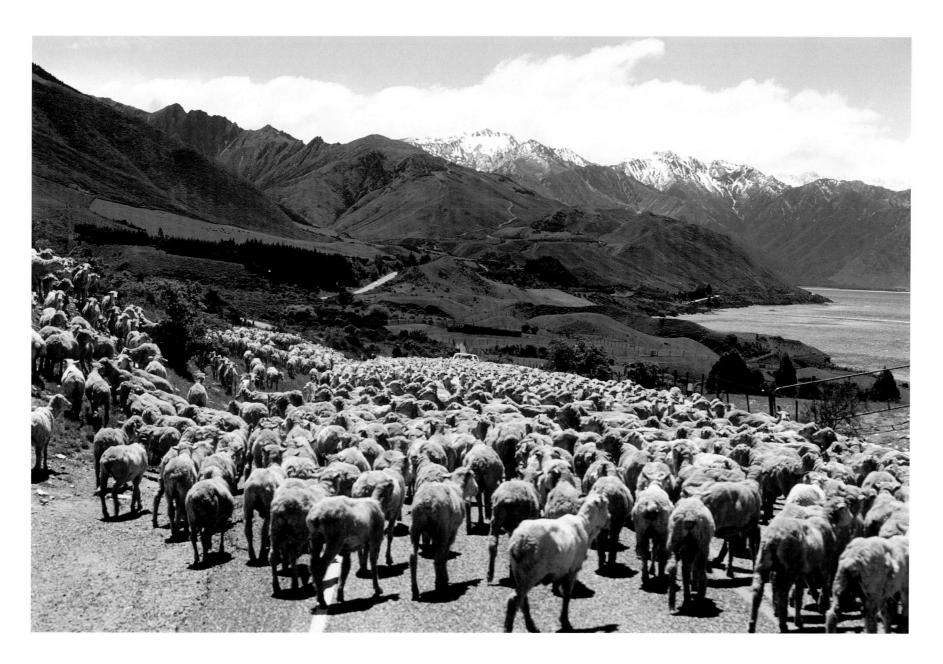

A mob of newly shorn sheep moving back to their pastures on the shores of Lake Hawea, Central Otago.

Detail of the Paua Shell inside the Paua Shell House in Bluff, Southland.

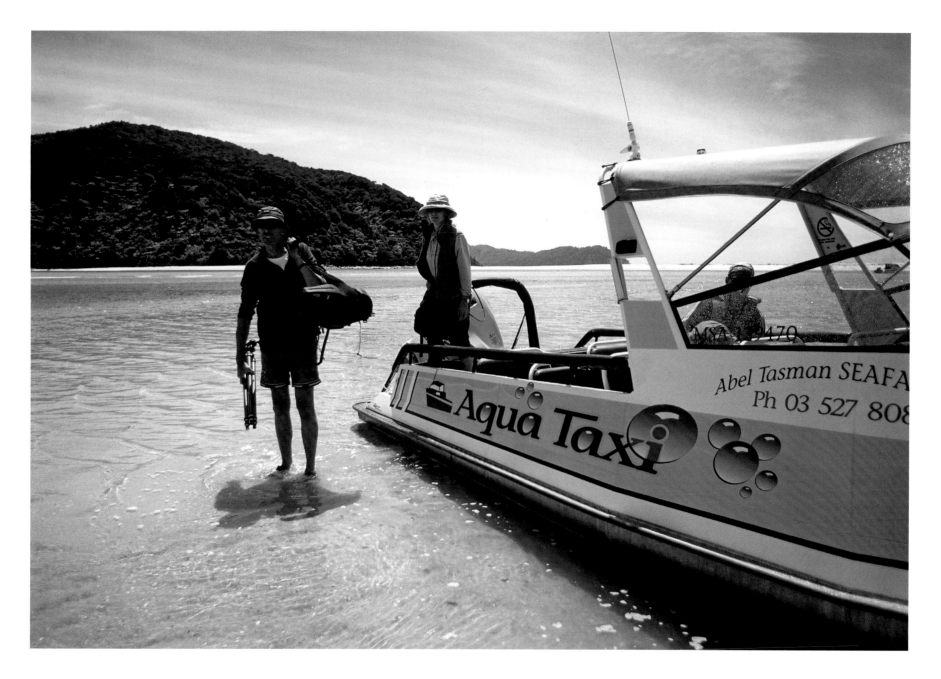

A water taxi on the Awaroa Inlet, Abel Tasman National Park.

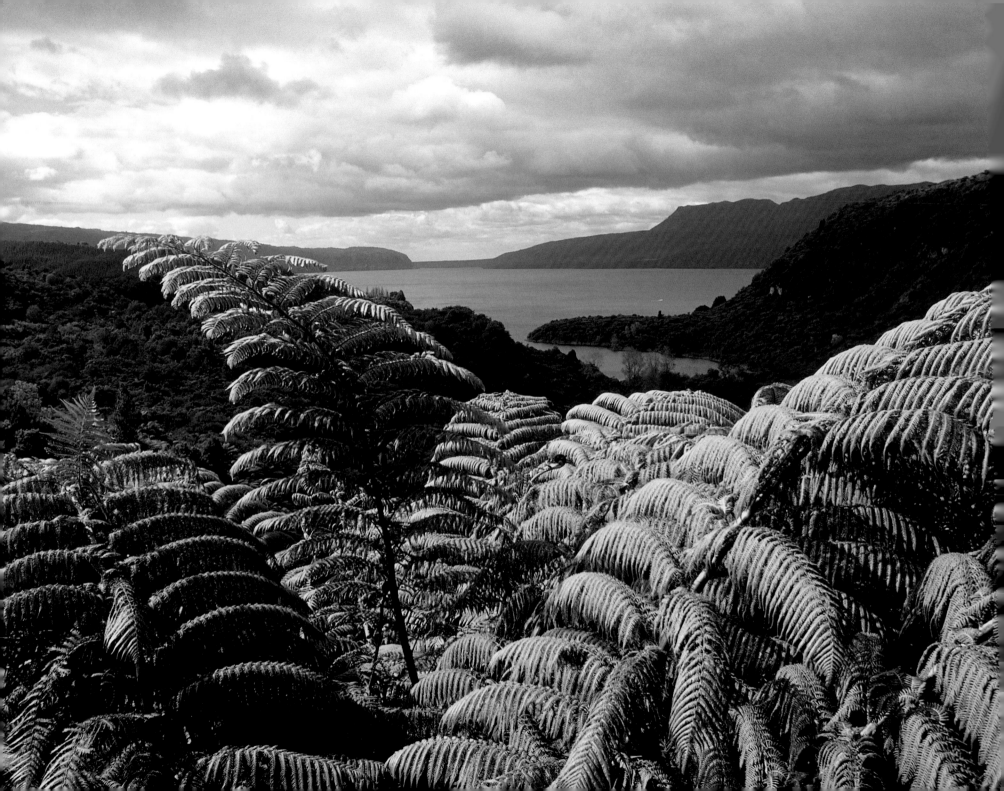

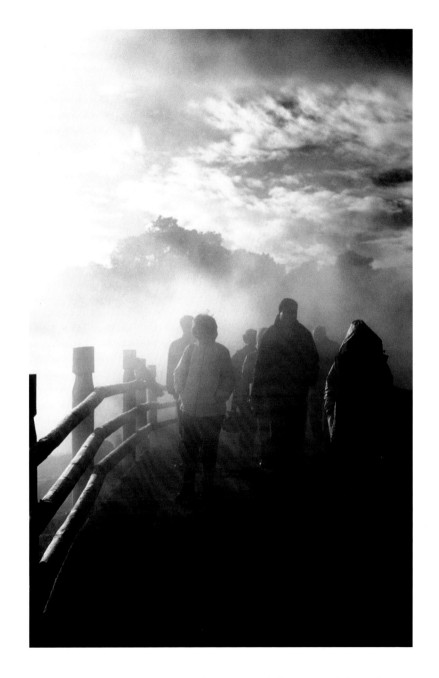

Silhouettes of tourists enveloped in the thermal steam at Whakarewarewa Thermal Reserve, Rotorua.
Opposite: Looking over bright green ferns towards Lake Tarawera, one of several scenic lakes around Rotorua.

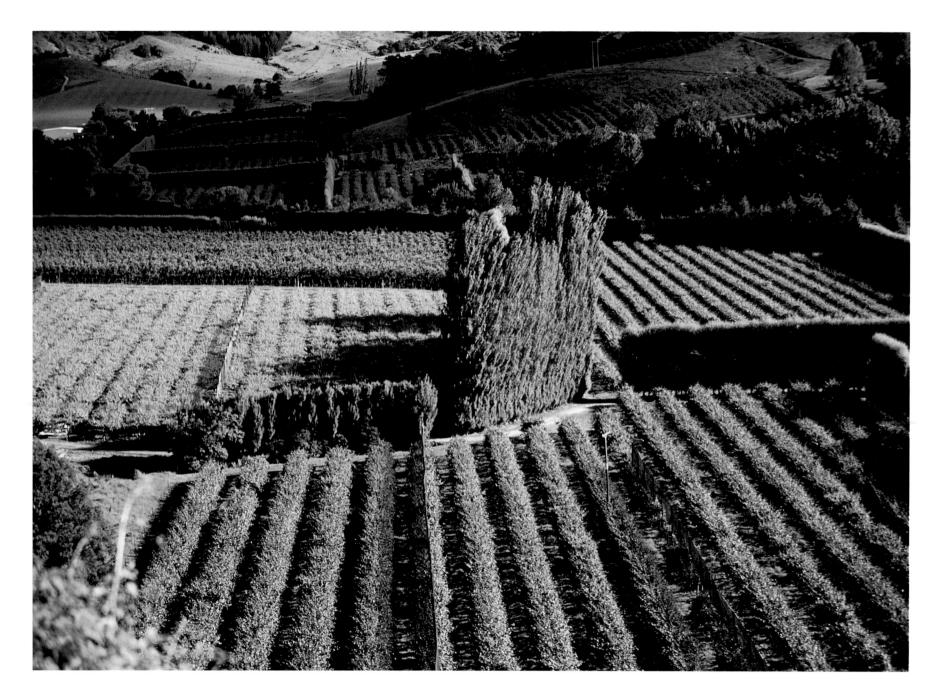

Orchards at Motueka, Tasman Bay

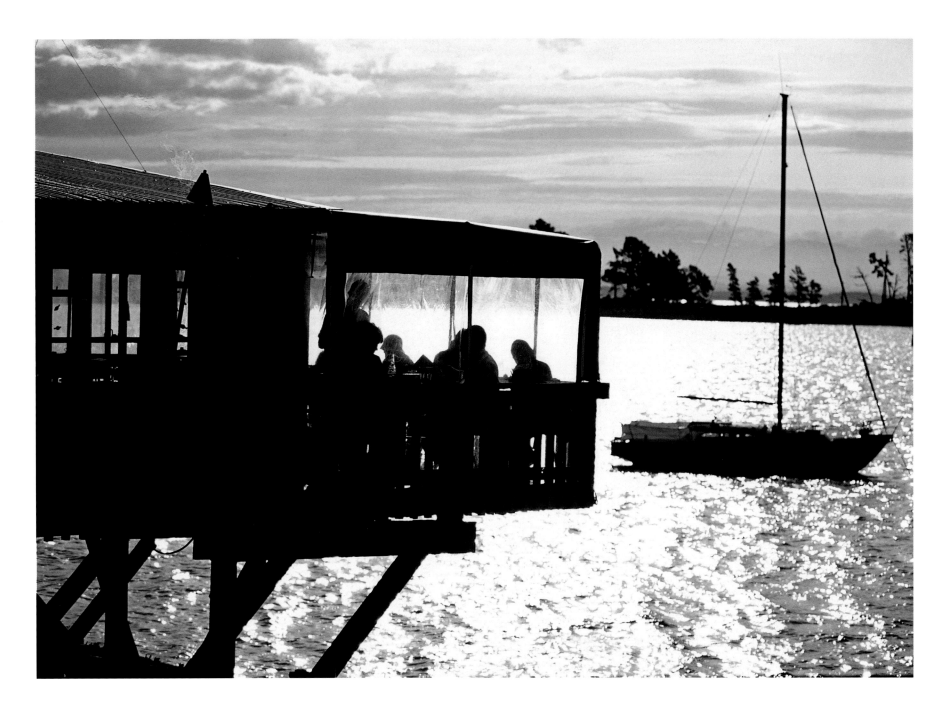

The Boatshed Restaurant, Nelson, Tasman Bay.

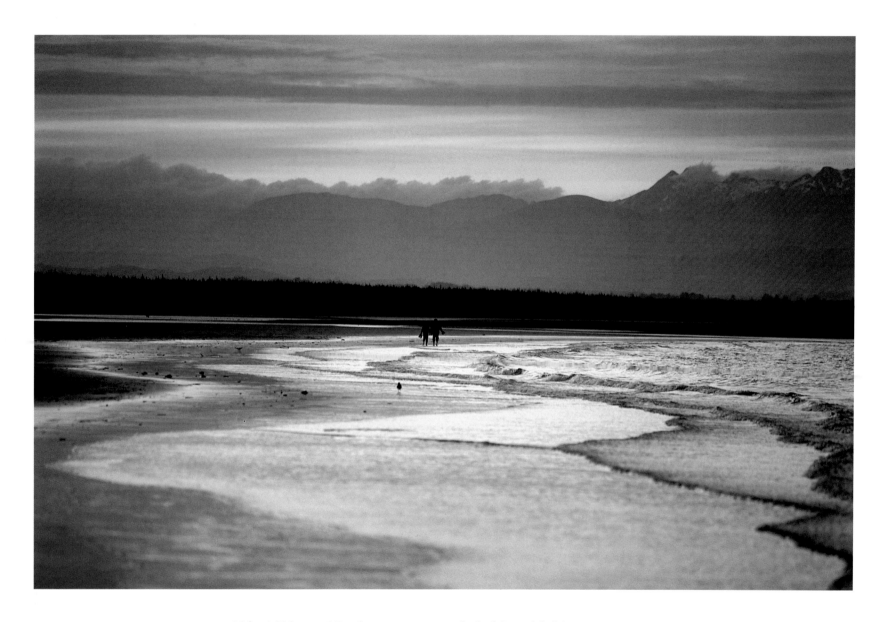

Nelson's Tahunanui Beach at sunset, against the backdrop of the Tasman Mountains.
Opposite: A bush-clad bay in Queen Charlotte Sound, one of the Marlborough Sounds.

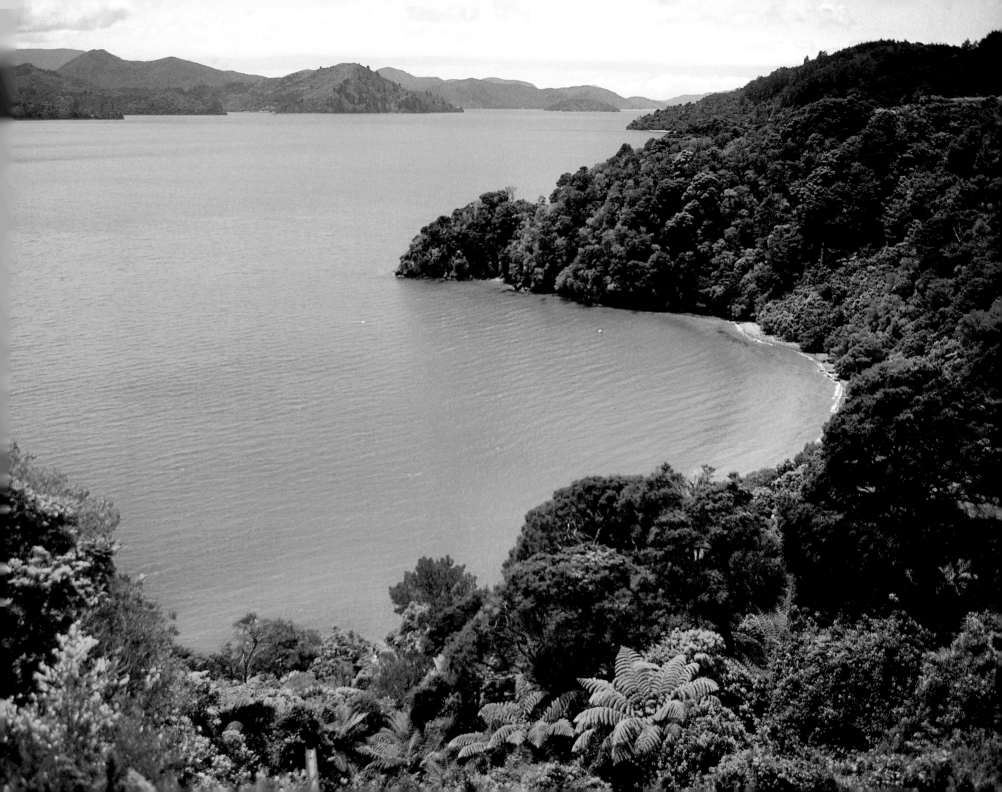

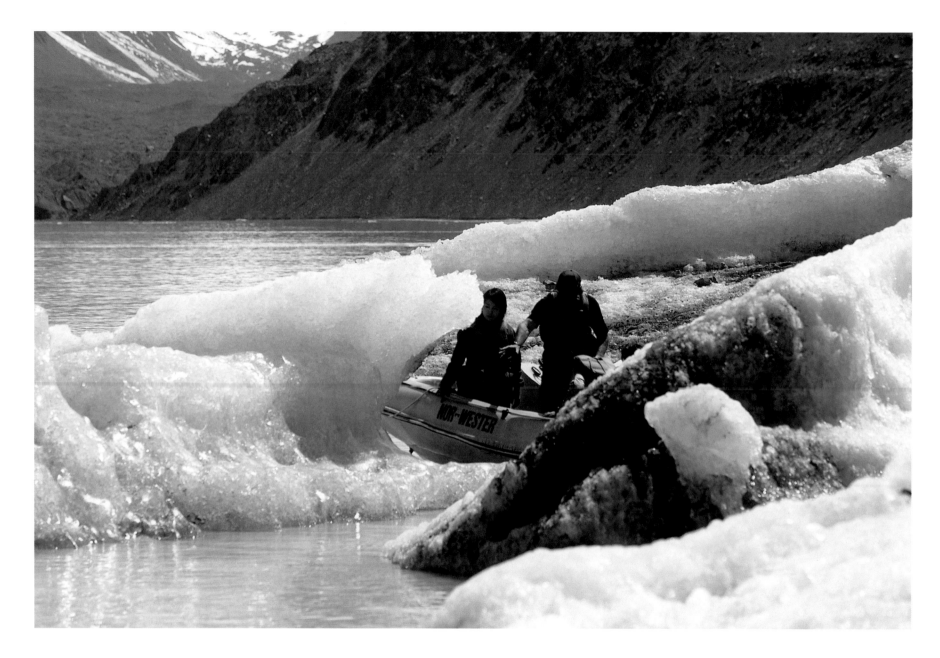

Tasman Glacier, Terminal Lake, Mount Cook National Park.

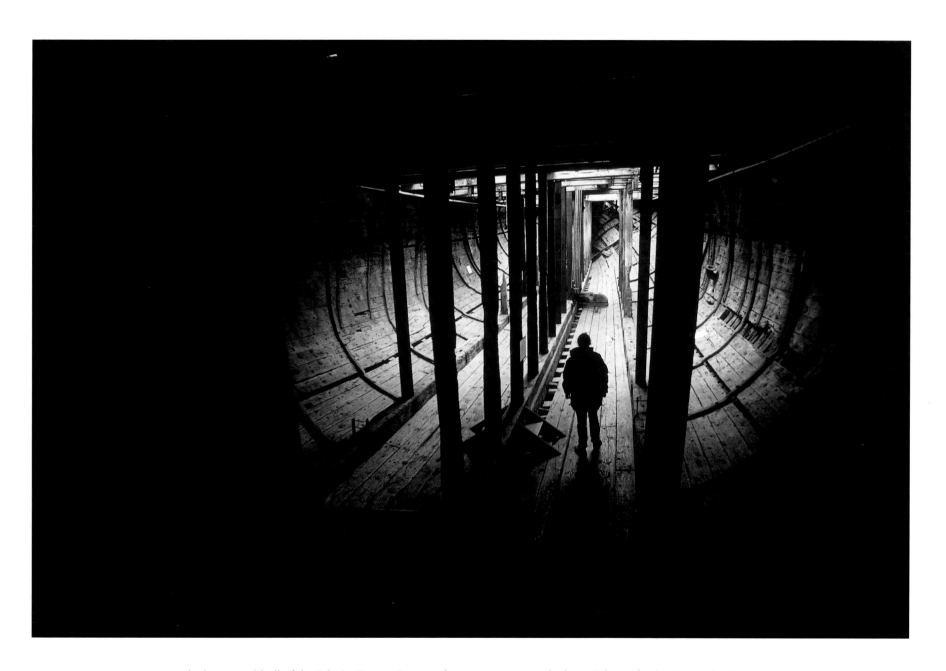

Inside the restored hull of the Edwin Fox *at Picton, a historic square rigger built in Calcutta for the East India Company.*

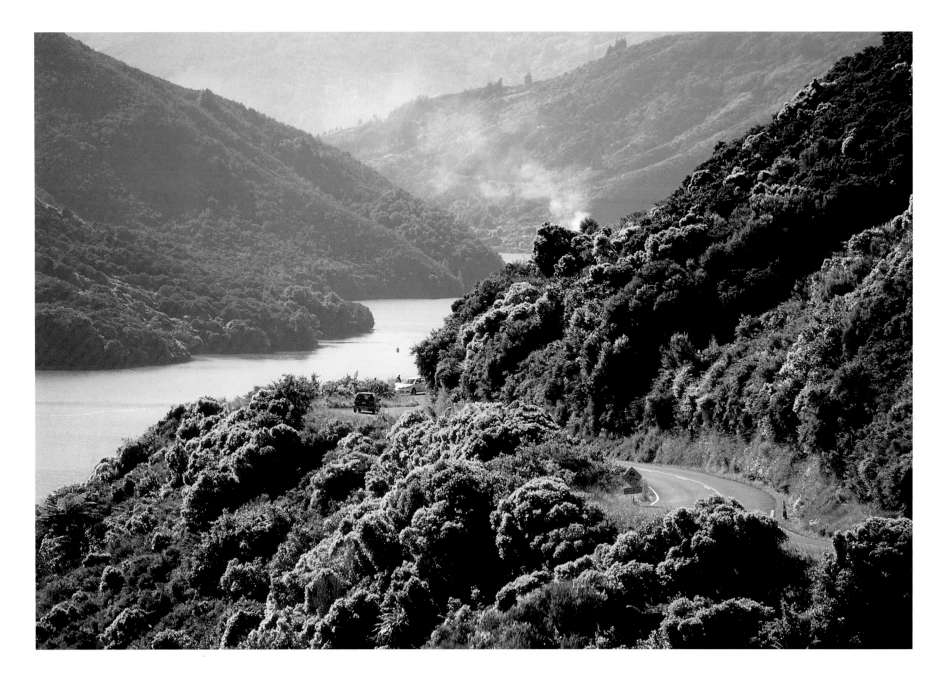

Queen Charlotte Sound Drive, Marlborough Sounds.

A kea, the New Zealand mountain parrot, at Willow Bank Wildlife Reserve, Christchurch.

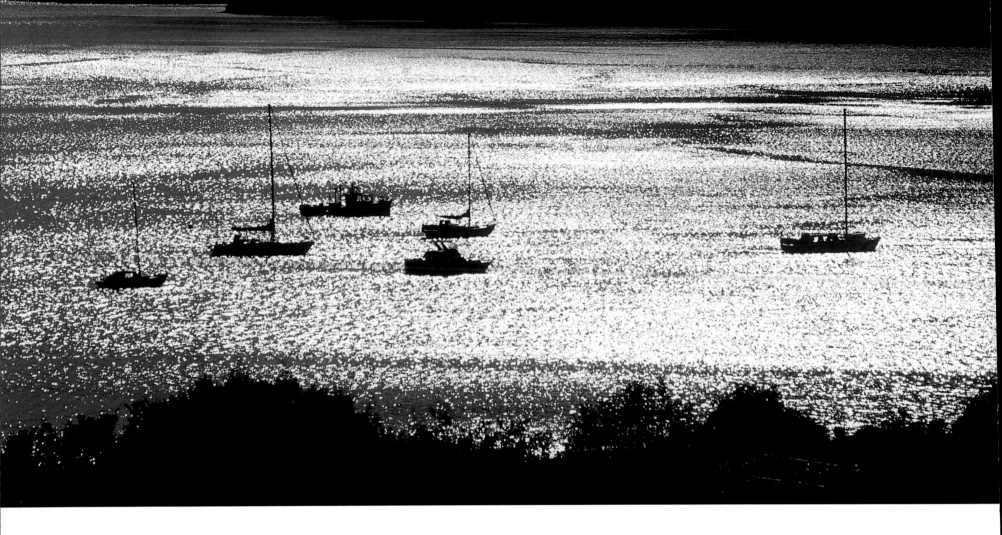

Boats silhouetted against the shimmering waters of Queen Charlotte Sound, Marlborough Sounds.

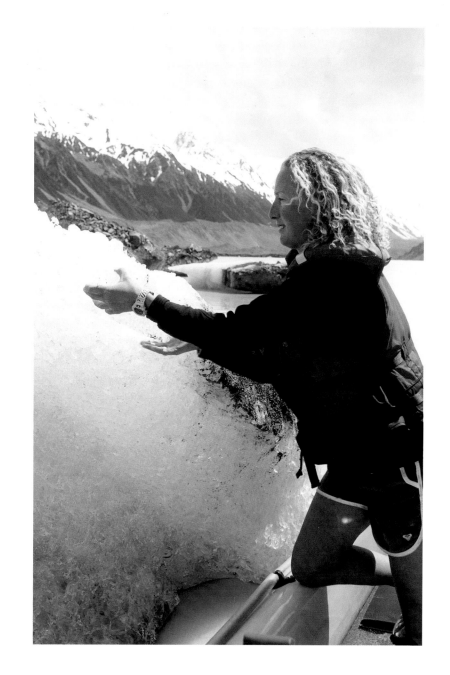

Tasman Glacier, Terminal Lake, Mount Cook National Park.

Te Waikoropupu Springs, near Takaka, Golden Bay.

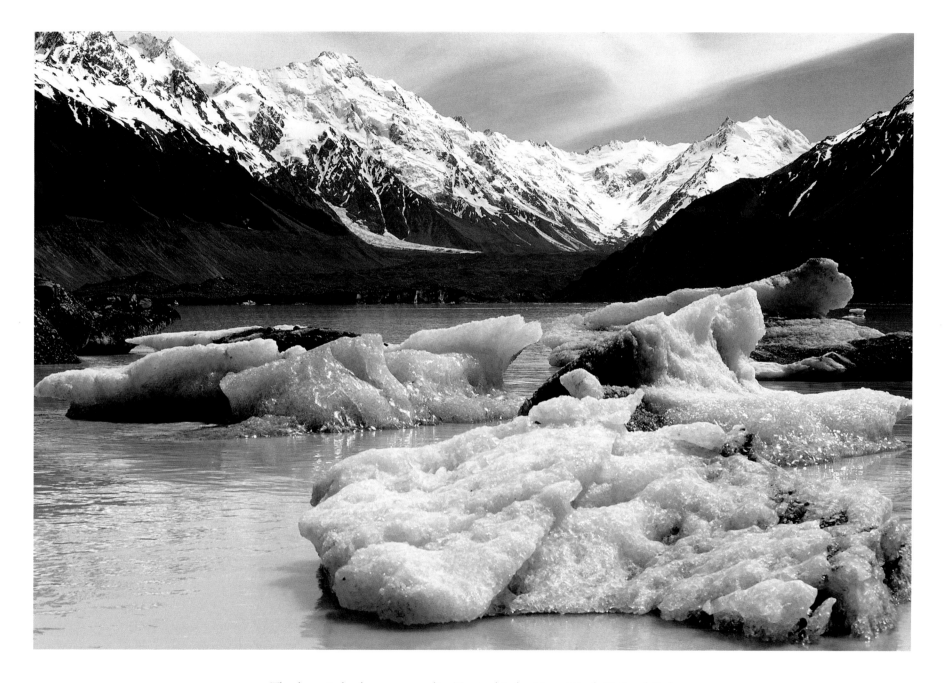

The dramatic landscape surrounding Terminal Lake, Mount Cook National Park.

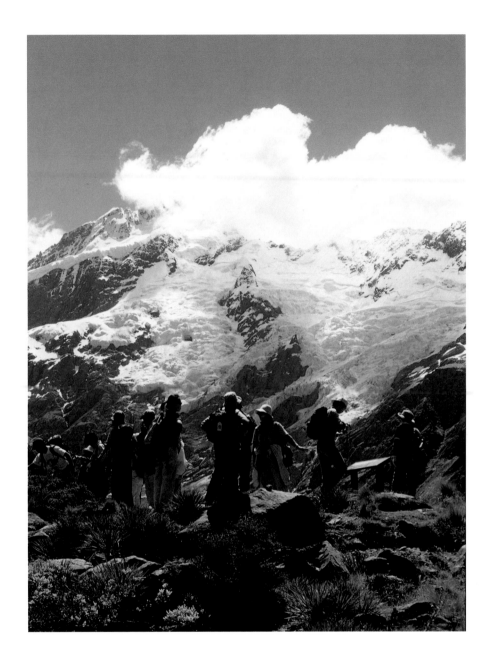

Hooker Valley Walk, Mount Cook National Park.

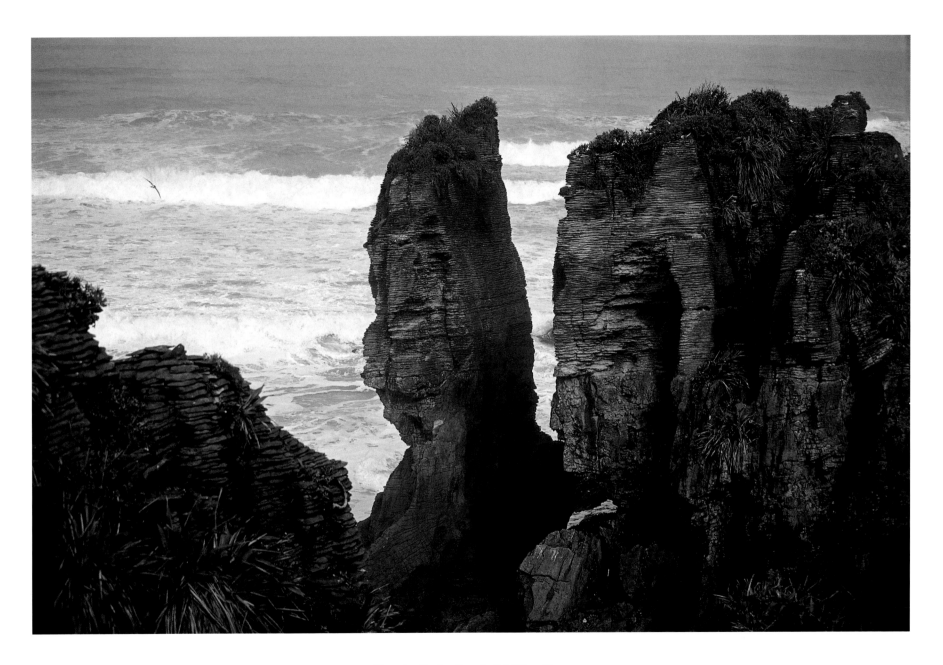

Pancake Rocks, Punakaiki, West Coast.

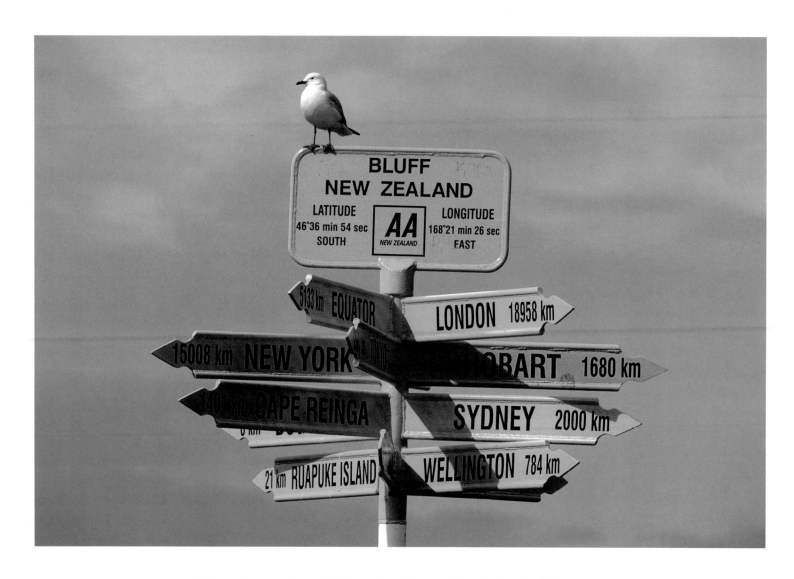

The southern terminus of Highway 1, which runs the entire length of the country.

Opposite: A lone walker strides toward his bach, the holiday home that is practically a birthright for every New Zealander.

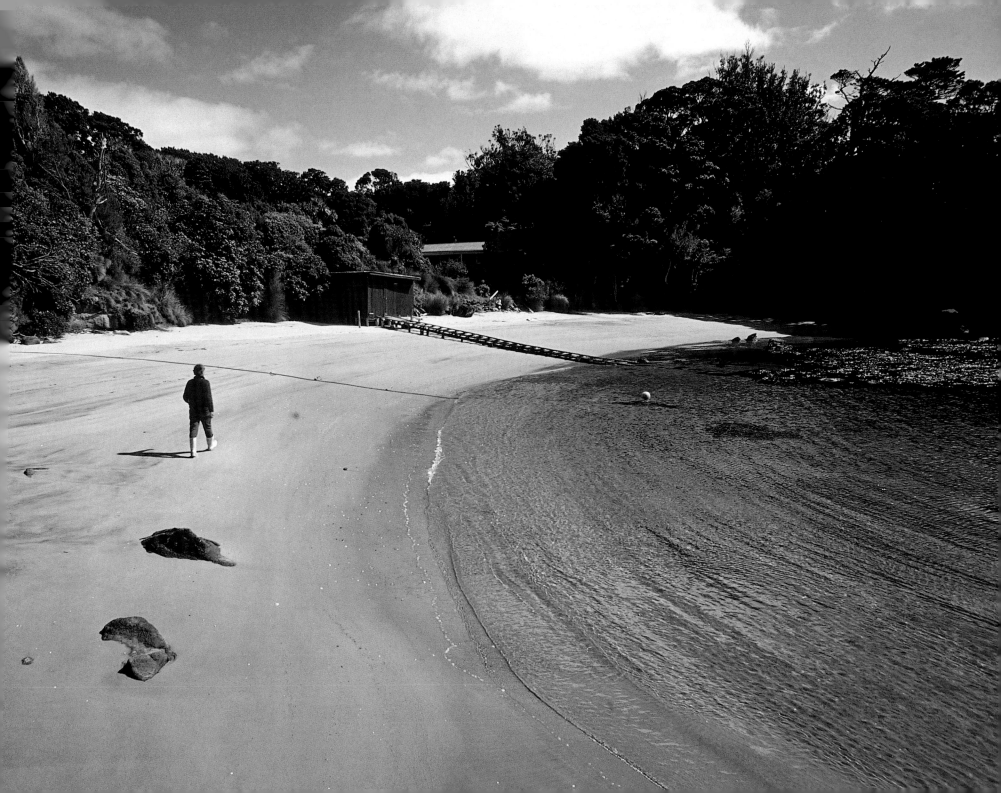

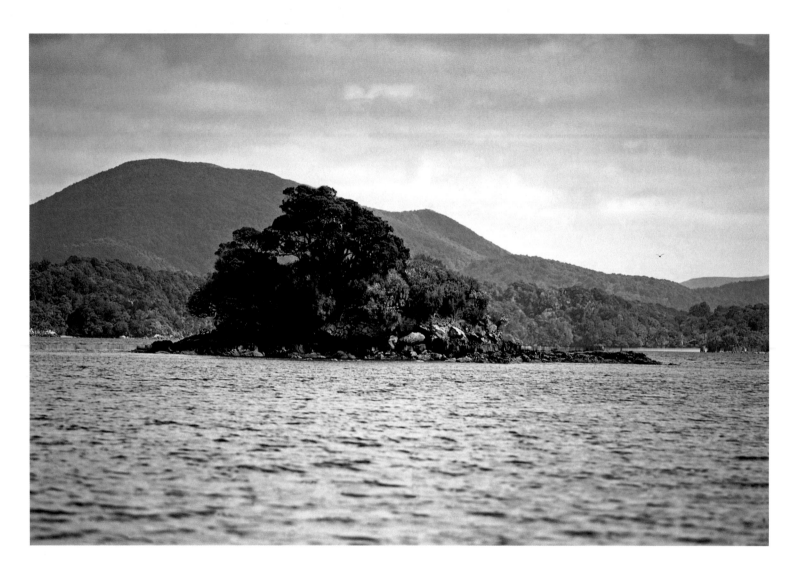

Patterson Inlet, Stewart Island.

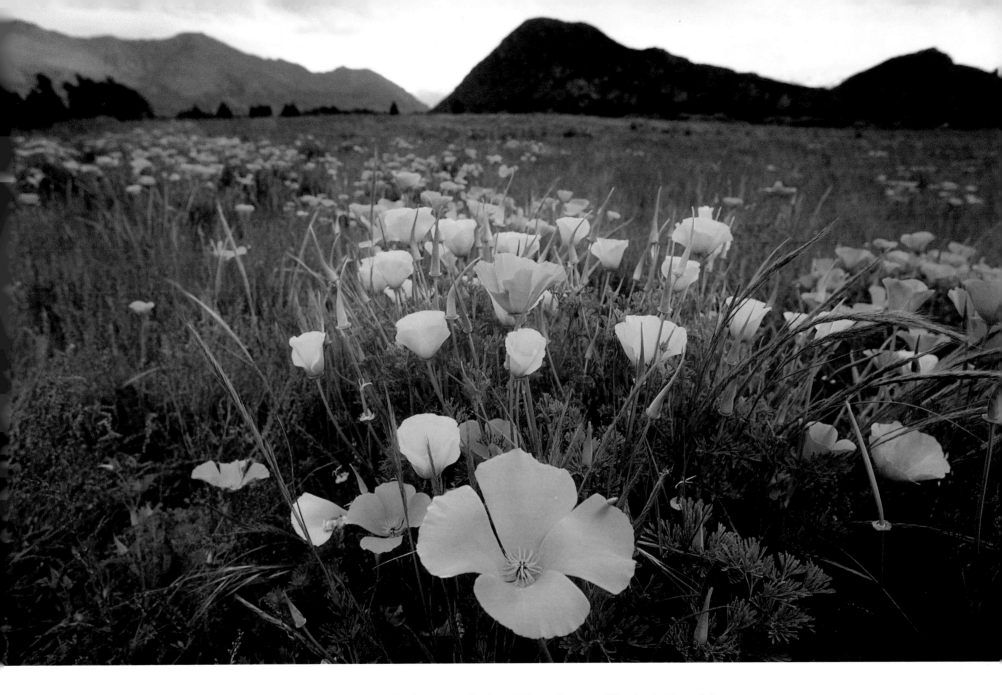

California poppies create a floral carpet at the foot of Mount Iron near Wanaka in Central Otago.

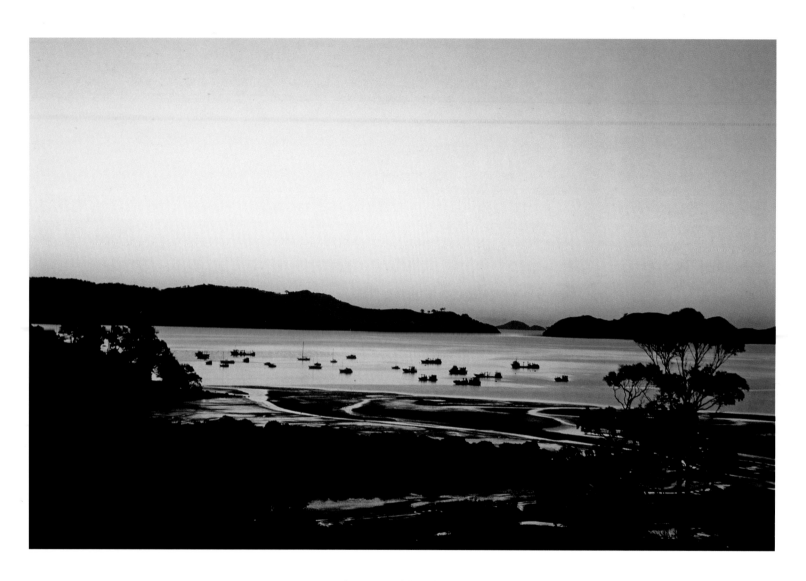

A view of Coromandel Harbour at sunset.

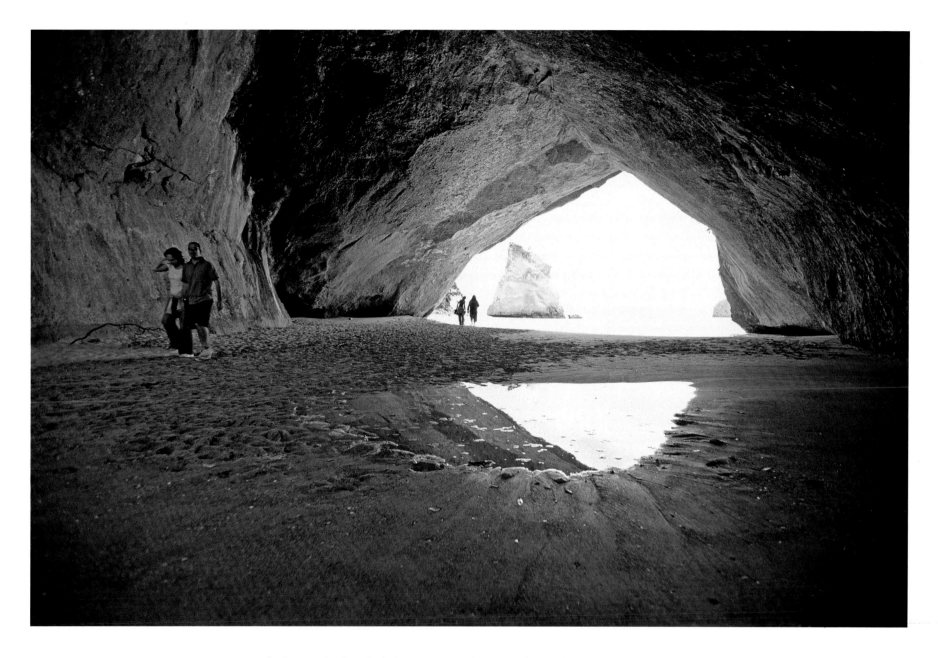

Inside the mouth of Cathedral Cove Sea Arch, near Hahei on the Coromandel Peninsula.

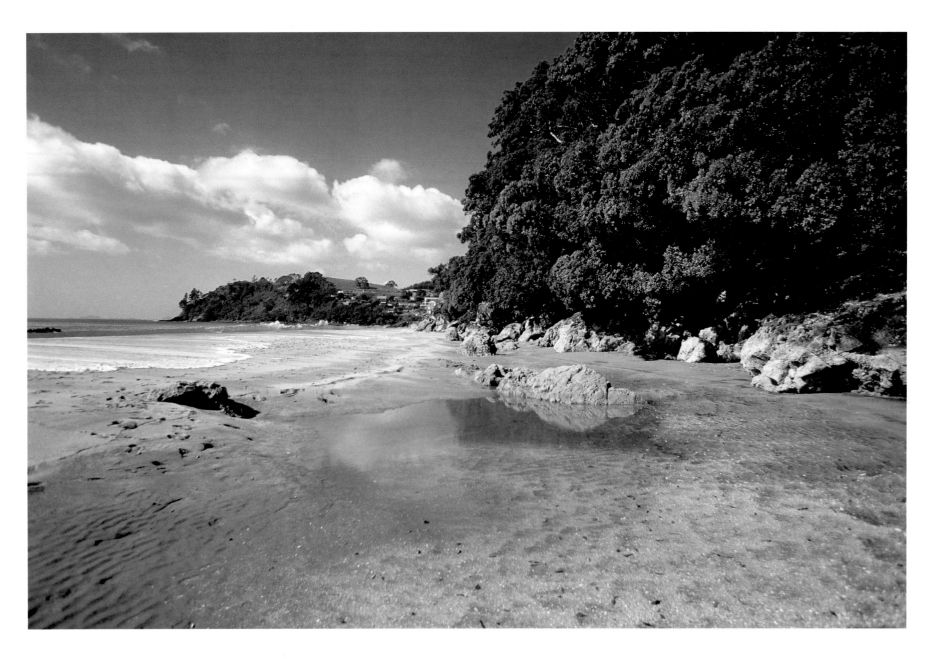

Hot Water Beach near Mercury Bay on the Coromandel Peninsula, where visitors dig shallow "spa pools" at low tide and wallow in the thermally heated water that flows beneath the sand.

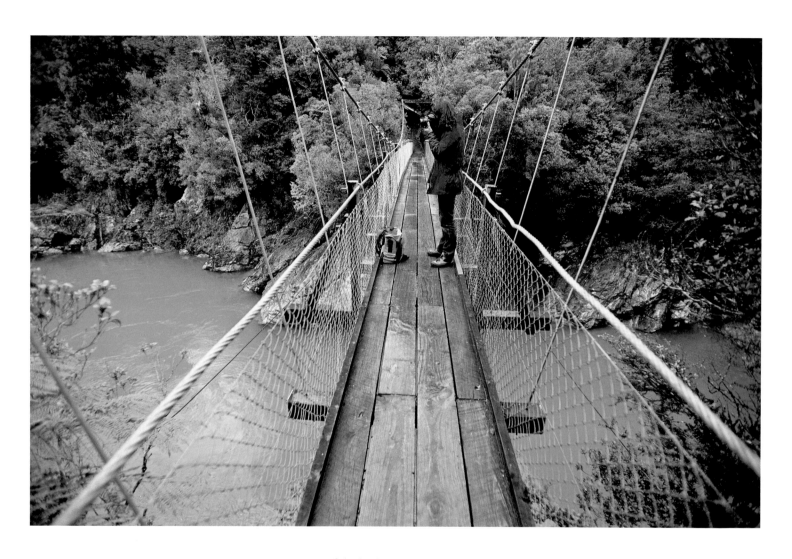

View of the bridge over Hokitika Gorge.

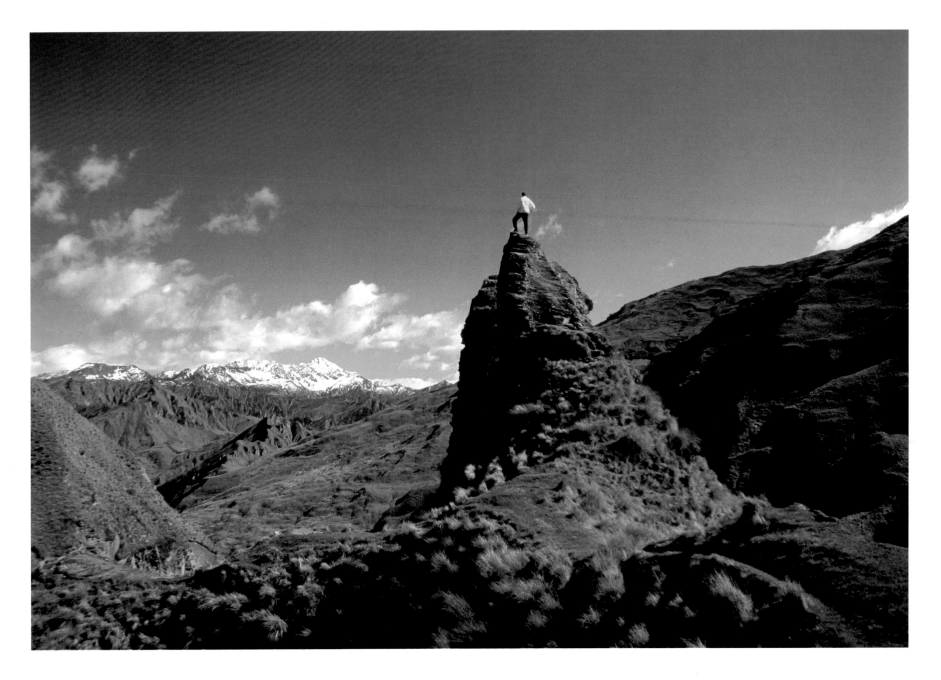

A hiker finds a vantage point from where he can survey all around him, here looking towards Mount Aurum from Skippers Road.

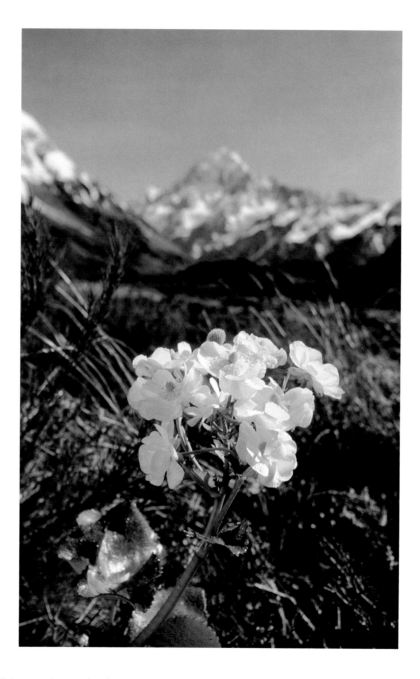

Detail of dew on the petals of a white lily growing in Hooker Valley at Mount Cook National Park.

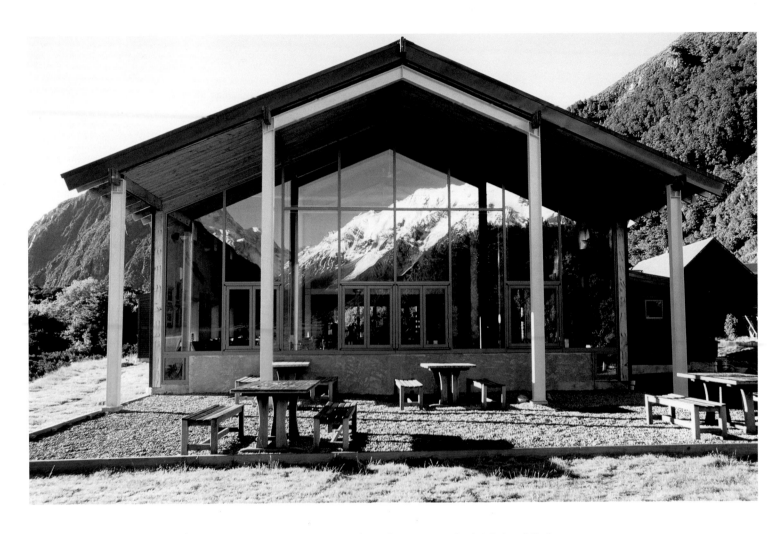

The Old Mountain Guide Cafe at Mount Cook National Park.

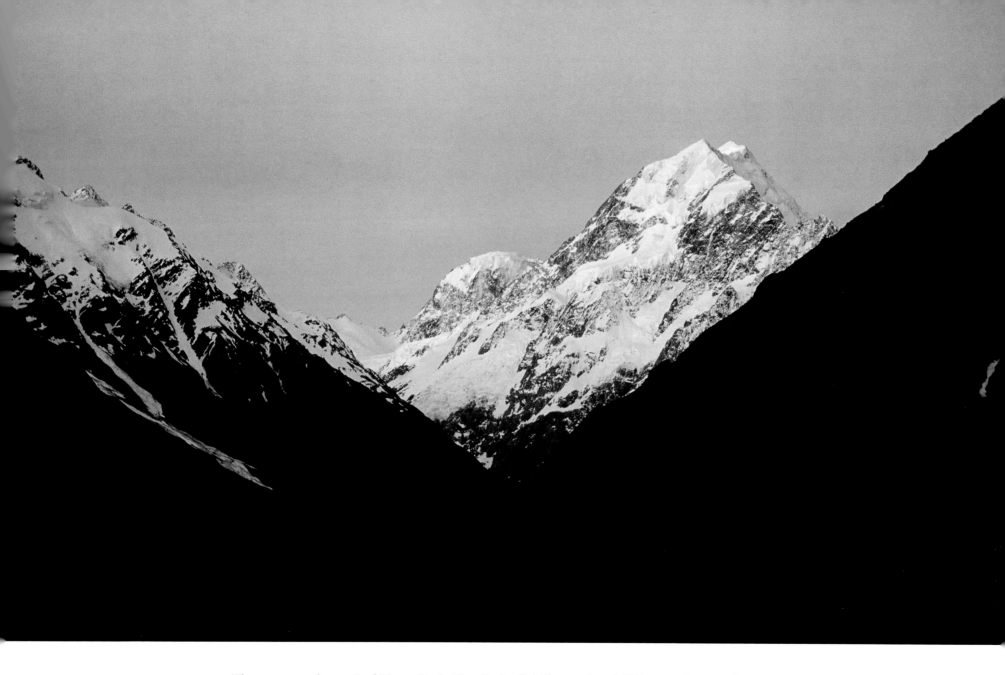

The snow-capped summit of Mount Cook, New Zealand's highest peak at 3,754 metres (12,349 feet).

View over Lake Wanaka to wooded hills beyond.

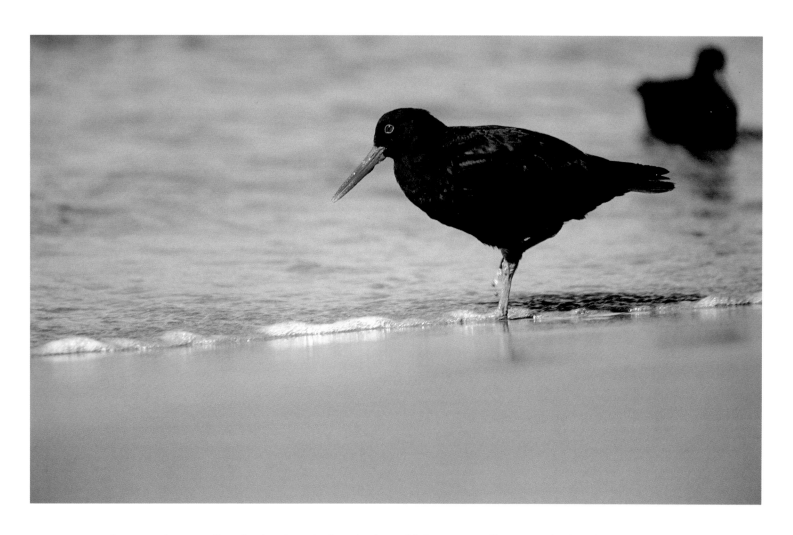

Oyster catchers patrolling the shoreline of Ulva Island, a wildlife sanctuary off Stewart Island in the country's south.

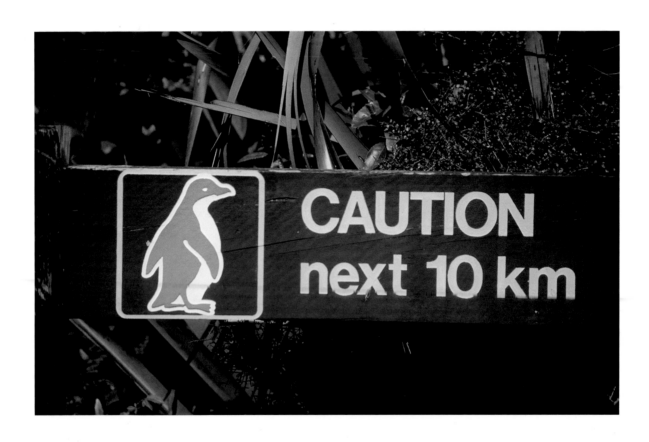

A sign at Cape Foulwind.

Anchor Stone, representing the Maori myth of the formation of Stewart Island.

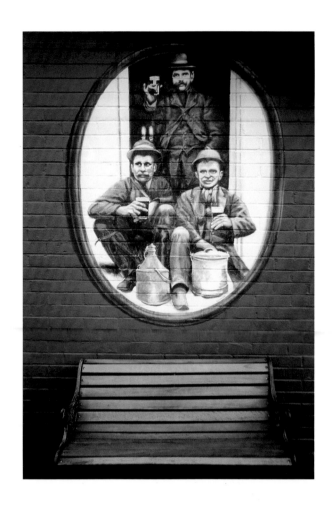

An image of thirsty West Coast gold miners sits above a bench at Monteith's Brewery in Greymouth.

Bush telephone, Stewart Island.

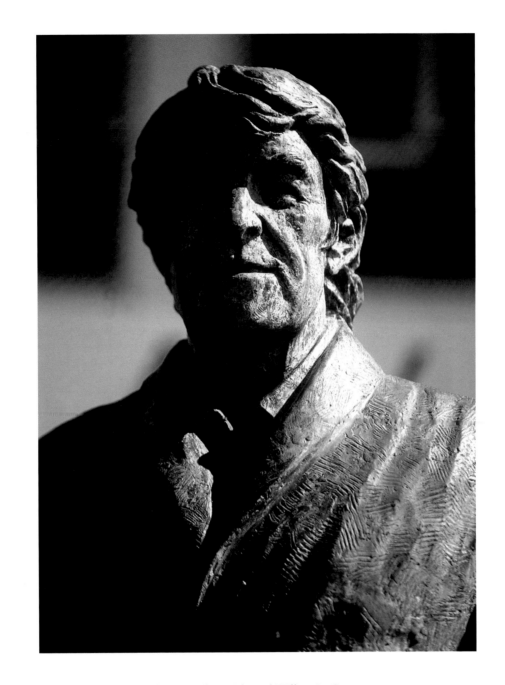

A statue of Sir Edmund Hillary in Orewa.

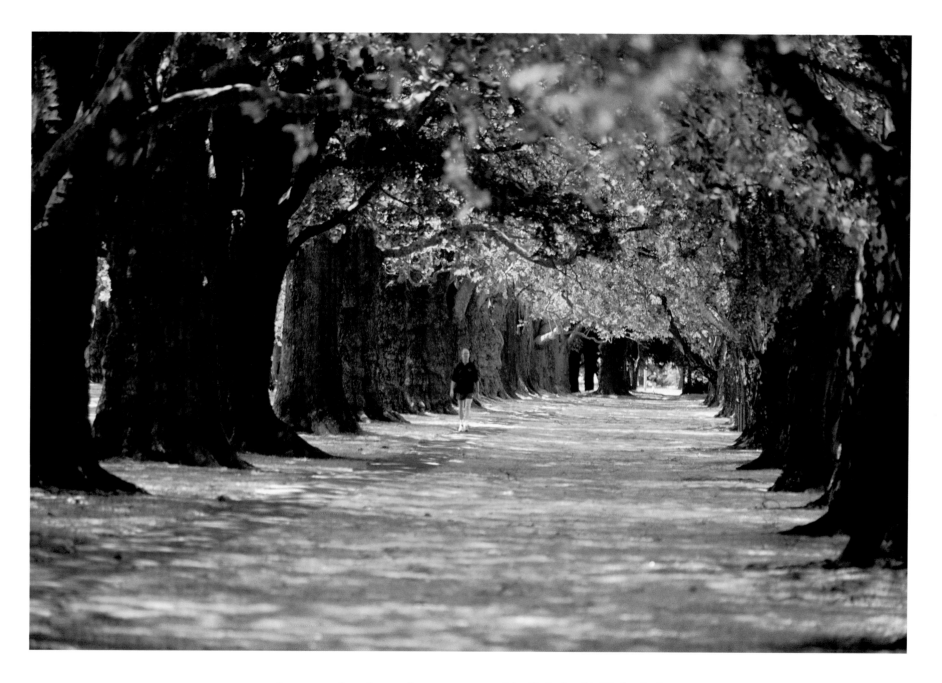

An avenue of stately trees forms a green tunnel in Christchurch's Hagley Park.

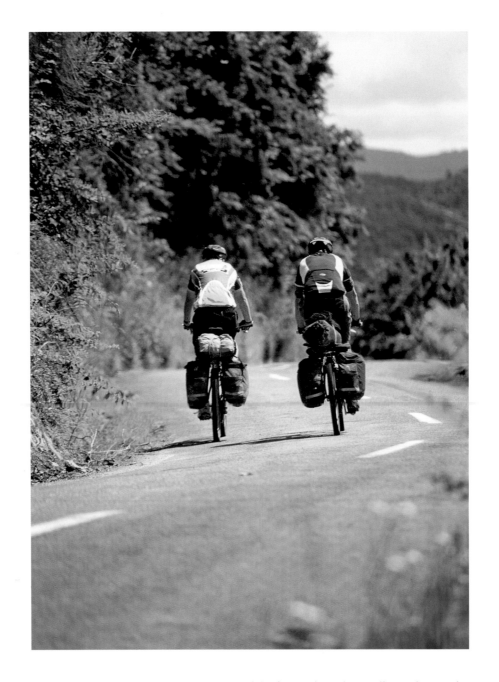

Touring cyclists on Kenepuru Road, one of the few roads in the Marlborough Sounds.

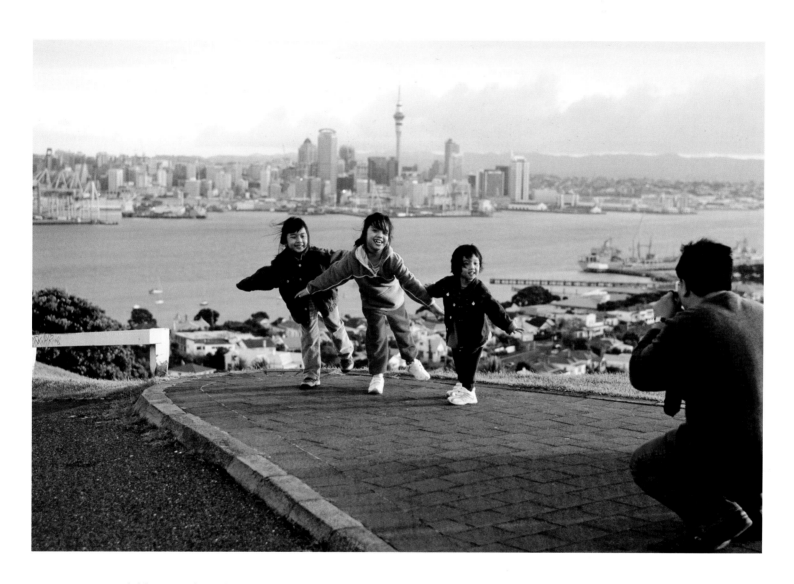

Children pose for a photo on Mount Victoria in Devonport, with Waitemata Harbour and Auckland city behind.

Auckland's Ferry Building provides a front-row seat on the city's harbour.

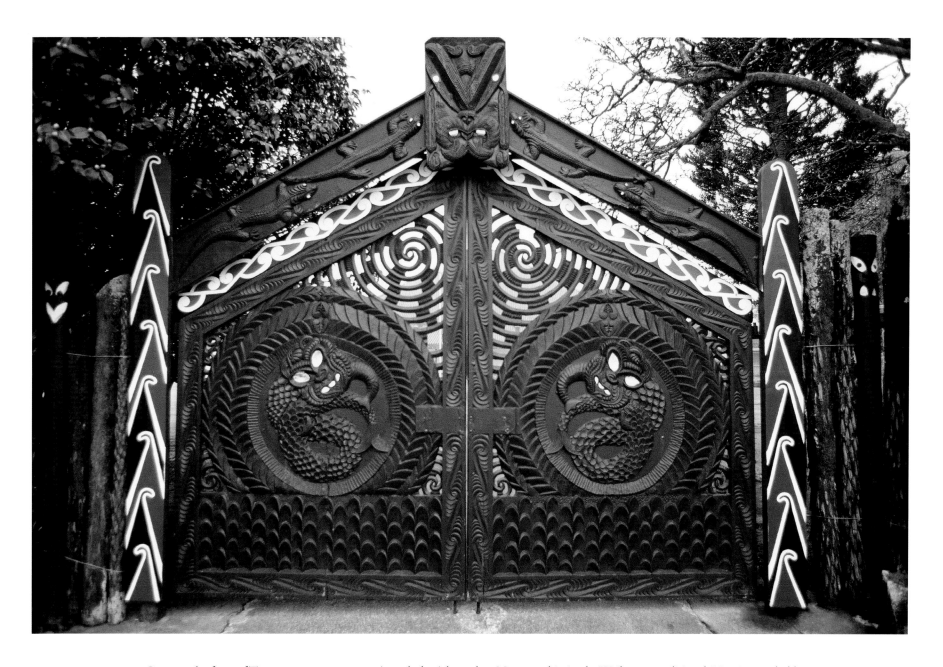

Gates at the front of Turangawaewae, a marae (sacred place) located at Ngaruawahia in the Waikato, a traditional Maori stronghold.

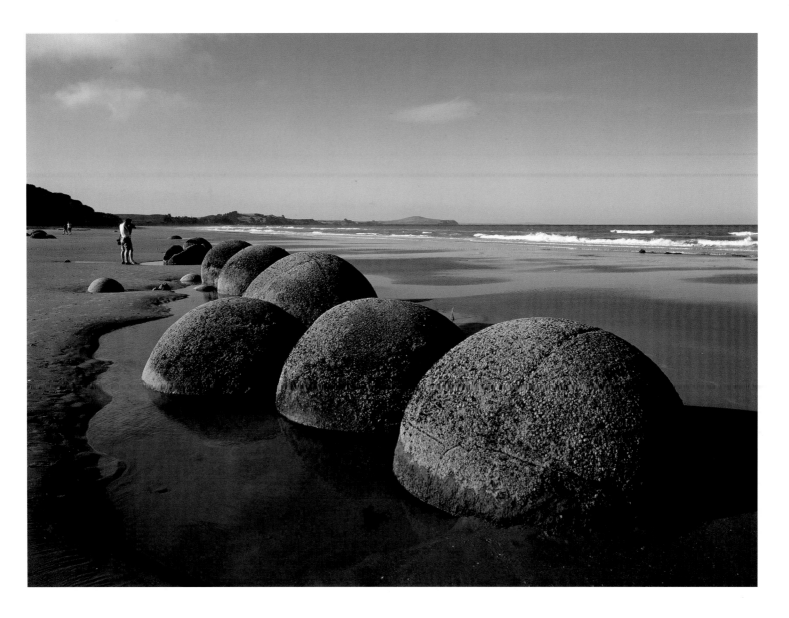

The dome-shaped Moeraki Boulders that dot the beach on the Otago coast.

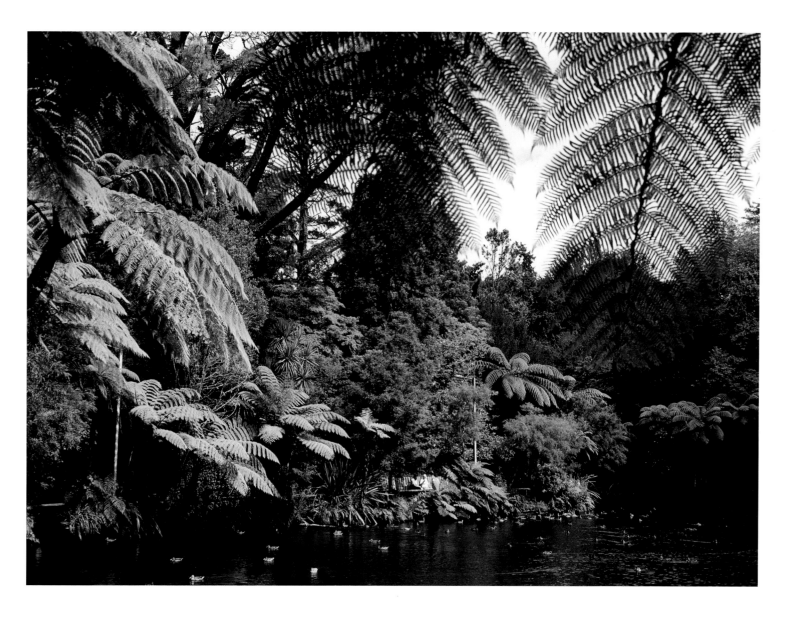

The symmetrical fronds of tree ferns surround the still waters of the lake in Pukakura Park in New Plymouth.

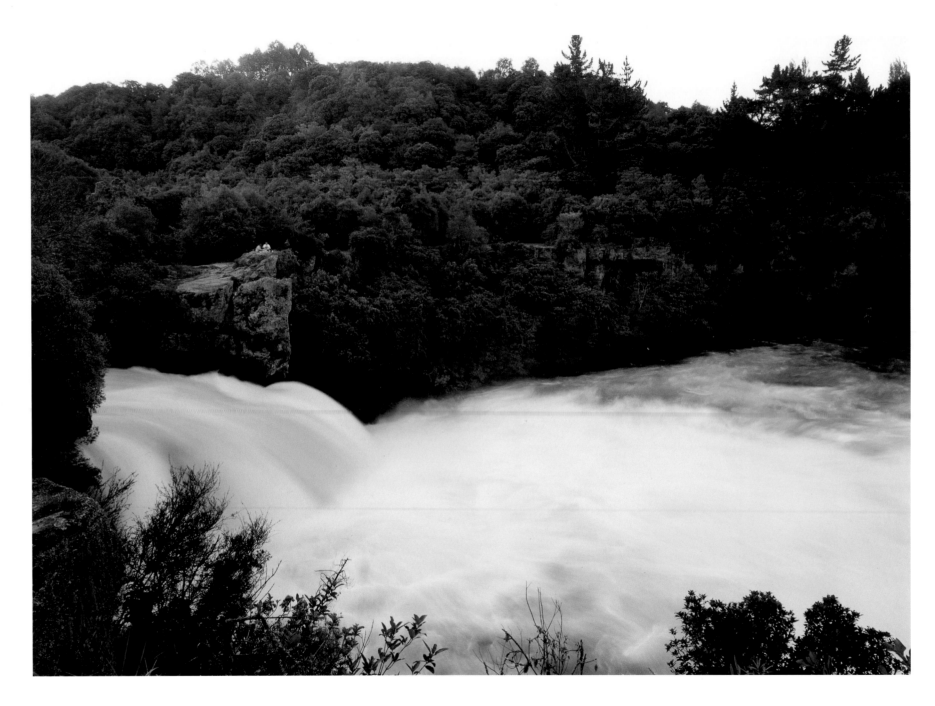

The Waikato River thunders over Huka Falls just before it enters Lake Taupo.

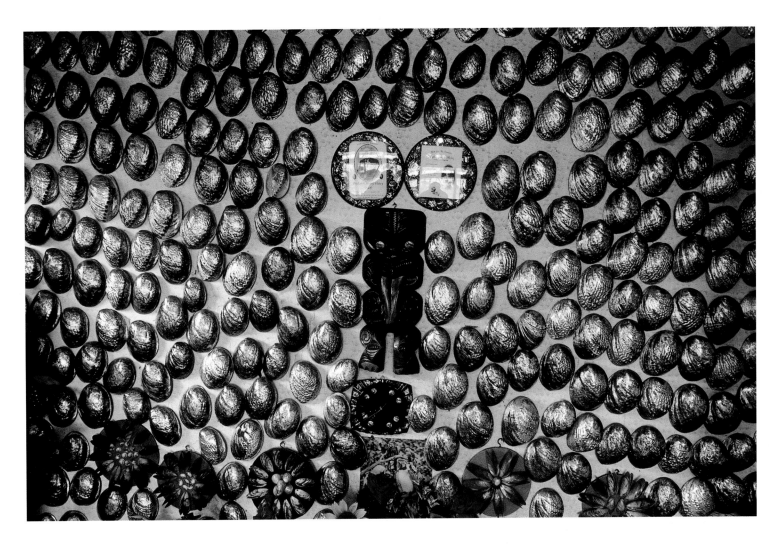

Paua Shell House, Bluff, Southland.

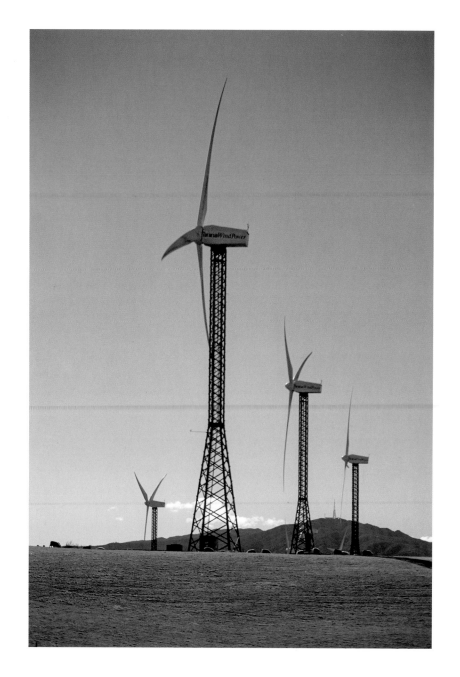

Four large wind turbines dominate the skyline on top of a grassy hill, part of the Tararua Wind Farm, Palmerston North.

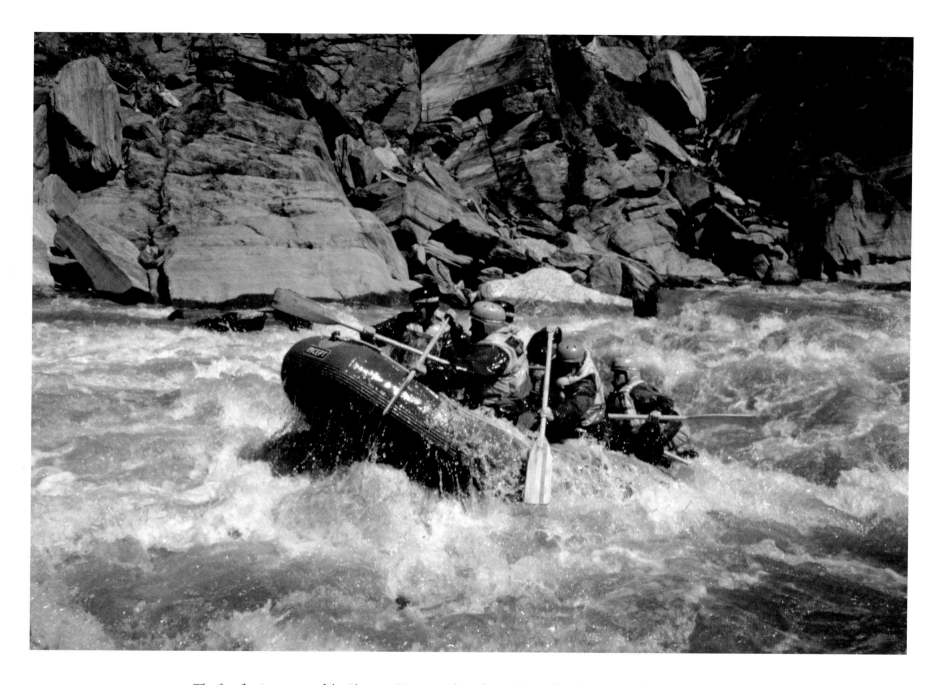

The fast-flowing waters of the Shotover River provide perfect conditions for white water rafting in Queenstown.

INDEX